Living Off the Sea

ON THE ISLAND OF CHAPPAQUIDDICK

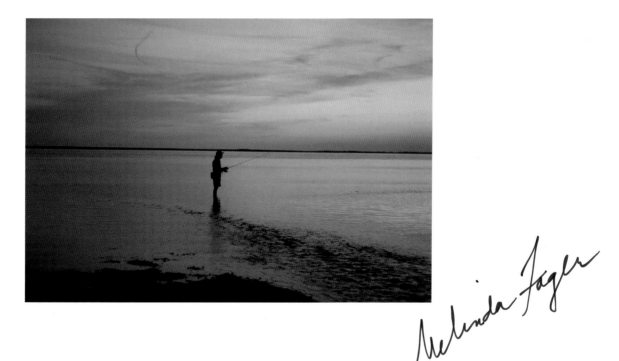

Melinda Fager

Melinda Fager

VINEYARD STORIES
Edgartown, Massachusetts

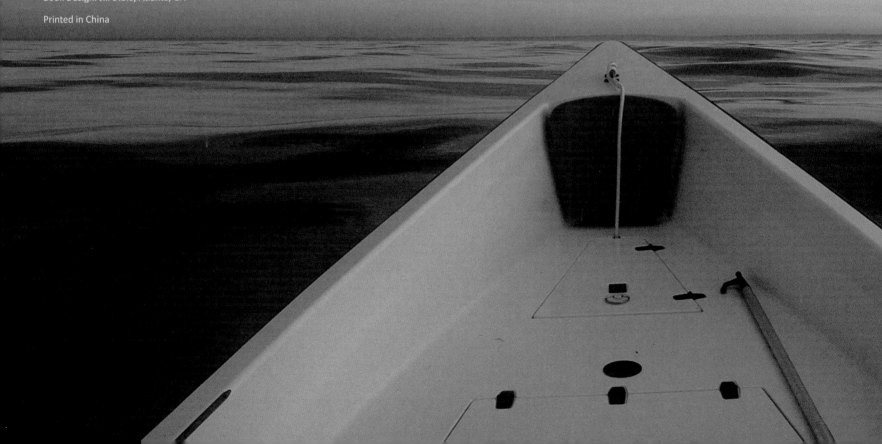

Published by Vineyard Stories
52 Bold Meadow Road
Edgartown, MA 02539
508 221 2338
www.vineyardstories.com

Photos courtesy of Jocelyn Filley: Pages 26, 69, 96, and Melinda Fager picture page 126
Photos courtesy of Jackson Fager: Pages 9, 20, 68, 76, and 98.
Photos courtesy of Chris Fager: Pages 28, 45, and Jeff Fager picture page 126
Photo courtesy of Nell Mednick: Page 41

Library of Congress Control Number: 2013931121
ISBN: 978-0-9849136-4-0

Book Design: Jill Dible, Atlanta, GA

Printed in China

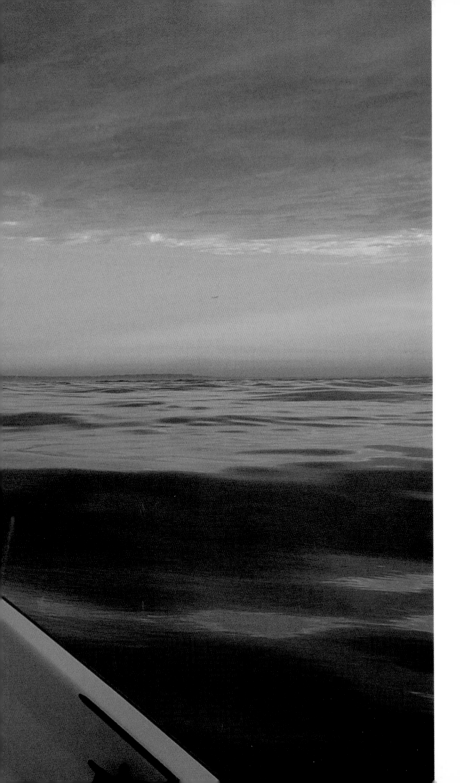

Contents

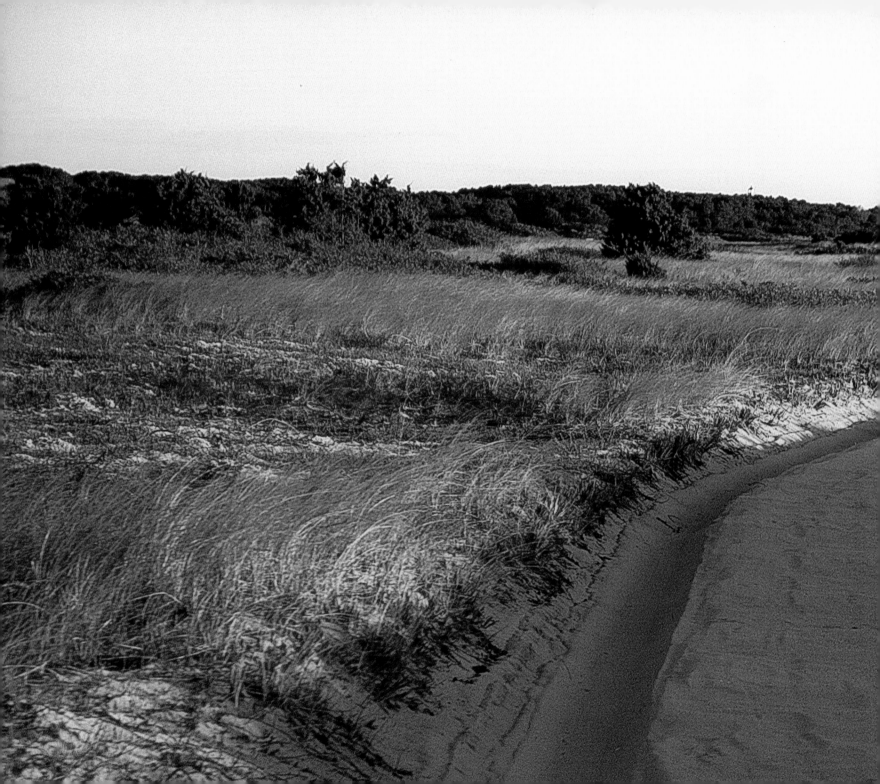

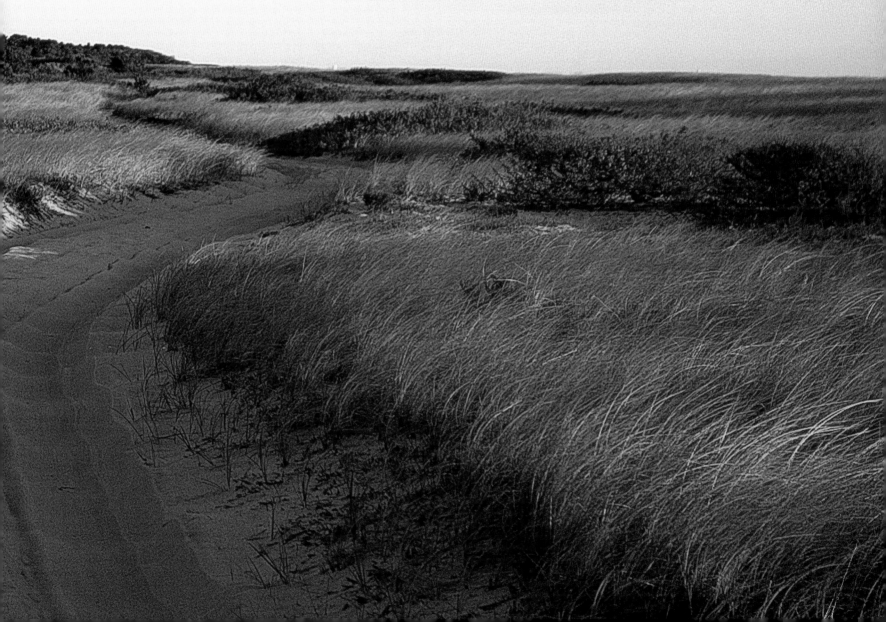

"All good things are wild and free."
—Henry David Thoreau

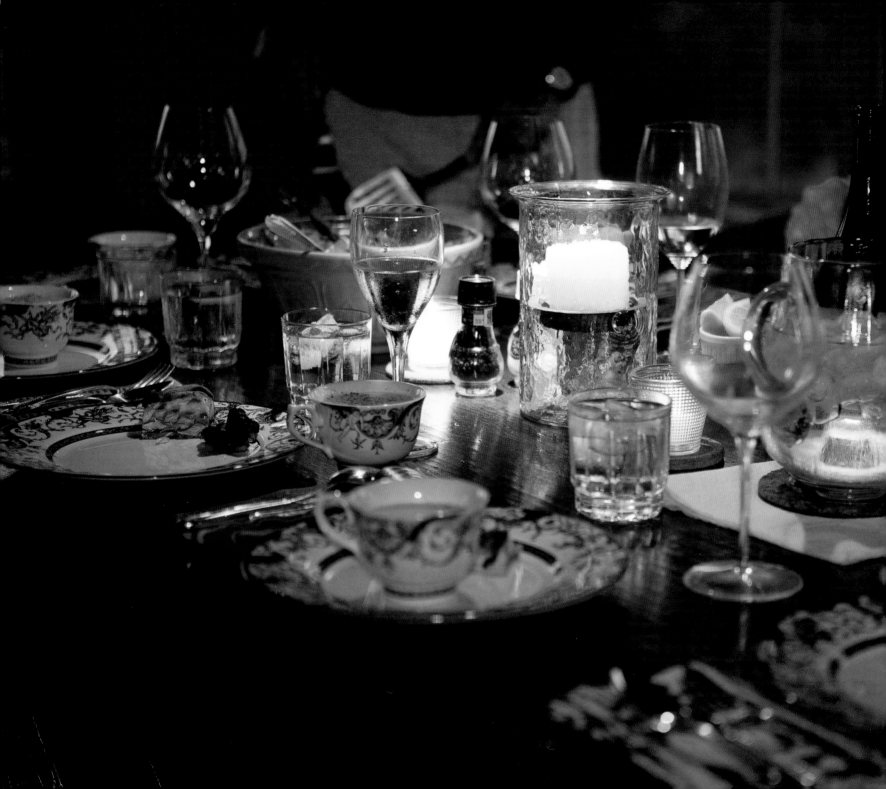

Introduction

Thoreau's quote "All good things are wild and free" begins this book because it captures the essence of our family's life in the summer on Chappaquiddick, the little island that's part of Martha's Vineyard but is separated by 527 feet of water.

My husband and I love the wild nature of Chappy and the vast seas that surround it. The untouched shorelines and the open ocean right outside our doors beckon to the fisherman in him and the cook in me. In the summer and fall months we are on Chappy we literally live off his daily catch along with the scallops, clams, and oysters from the bay; berries from wild patches; grape leaves tumbling over fences and stone walls; and fresh vegetables from our local farms.

Chappaquiddick has been a constant in what has been a full life since we met right out of college when I was a graphic designer at WBZ in Boston and Jeff was the gofer who collected those graphics and delivered them to the studio. So much has happened in thirty years of marriage, but for us Chappaquiddick has stayed the same.

No matter where we have lived or what stage in life, Chappy has been our refuge and our retreat. Each year we look forward to the roar of the nearby sea, the smell of the salty tidal waters, and the smoke wafting from the fish on the grill. This island life has been invaluable as a place to replenish the spirit and spend unhurried time with our family and friends.

We also use our time here to challenge ourselves to eat totally local.

Some people are born to be fishermen, and Jeff is one of them. When he caught a bluefish on our honeymoon thirty years ago on Chappaquiddick, I couldn't know that would be the beginning of what would become the basis of our summertime lifestyle, passed down to our three children.

Over the years he's brought in bluefish, striped bass, bonito, and even shark. With such an abundance of fish, it became our challenge to live off whatever he caught. Our recipes evolved over the years, from the early days when our children were young and we grilled our fish in tinfoil on the beach to the three-course feasts we've enjoyed at our cottage.

Together we have built a collection of our favorite recipes for just about everything we've caught or foraged on Chappaquiddick, and they are included in this book. They are very basic and simple, with the common element of freshness. This is not a definitive book on cooking seafood, but I can say with confidence that the recipes we've developed over the years are delicious and may take you by surprise.

This book is also an opportunity through photography and words to take you on a tour of this spectacular place we call home in the summer months. The island is still so wild and untouched, and every day I explore it with my camera to find something that captures some of its endless beauty.

Along with photos, we offer you another view from our friend Brad Woodger, who has deep roots on Chappy and whose essays are identified in the book by his initials, B.W. He tells you the story of the island in words, just as I tell you in photos. Brad writes a column for the historic *Vineyard Gazette* newspaper, and in this book his essays describe some of the wonders of the island. Dana Gaines, another friend and neighbor, embellishes these pages with his beautiful line drawings.

So consider this book to be an invitation to join us for breakfast, lunch, and dinner, and share in the many pleasures of our island life.

—Melinda Fager

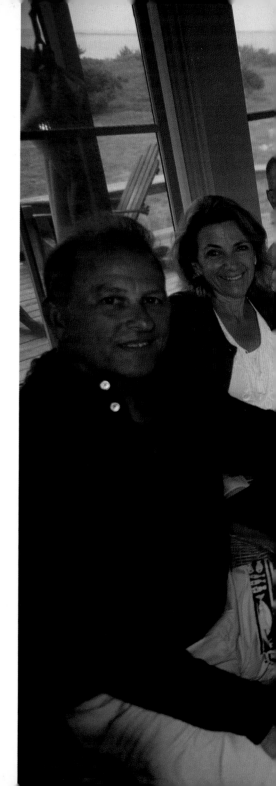

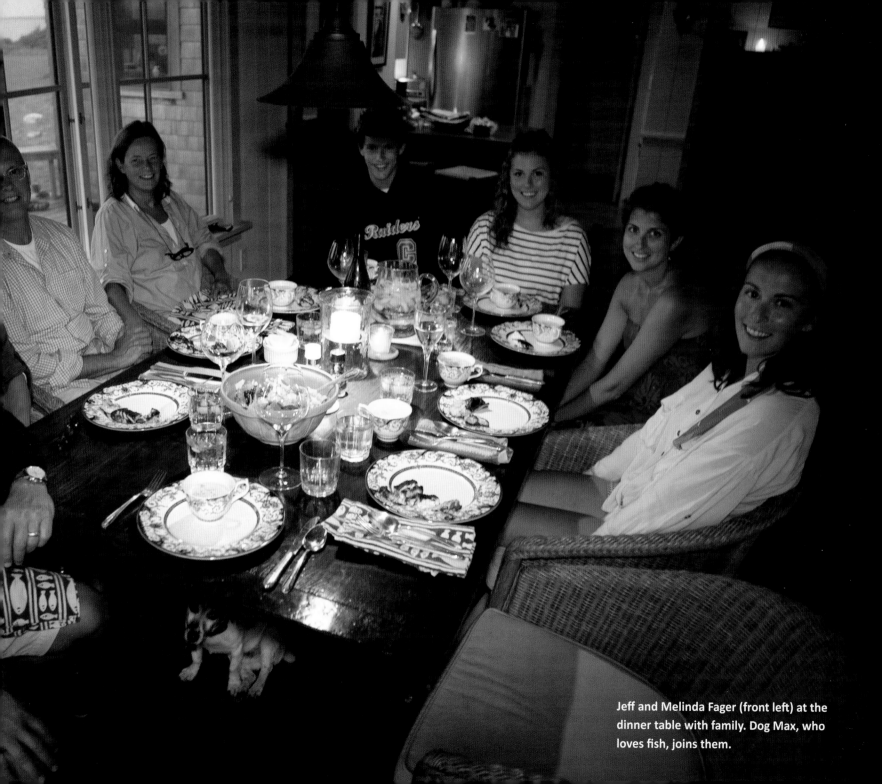

Jeff and Melinda Fager (front left) at the dinner table with family. Dog Max, who loves fish, joins them.

Chappy Ferry

There's a wonderful feeling of anticipation when we board the first ferry at Woods Hole for Martha's Vineyard. The forty-five-minute trip transforms us. All that we've done in the past months is left behind, and our attention is now focused on what's ahead.

Yet we don't truly feel that we've fully escaped until we board the second ferry—the little three-car Chappy ferry that brings us from Edgartown to Chappaquiddick Island. We drive up the ramp and onto the narrow barge. The car engine is turned off, brakes are set, the chains clank behind us, and the ferry motor revs up signaling that we are released from the big island. All our senses come alive. We recognize the sunlight on the harbor and the familiar fishing boats at their usual moorings, the smell of the tidal water and the sound of the gulls overhead.

We're back.

We're home.

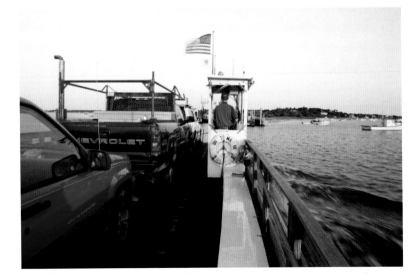

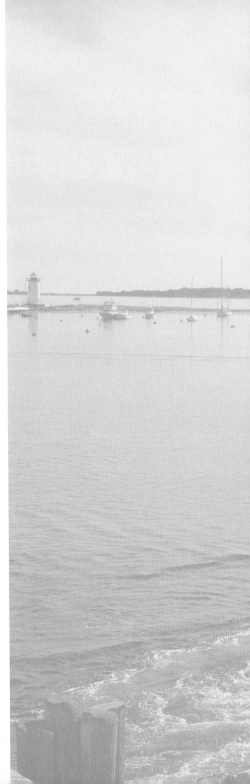

The Passage

I wonder if there is another place like Chappy—a place quite so remote and yet accessible. Popular in its natural beauty and unpopular in its lack of anything commercial "to do." Populous and underpopulated. Maybe what separates us from most other places is our location—tantalizingly close to being connected, yet untethered. True, we are anchored to our spot by the land below water, just as the "Big Island" of Martha's Vineyard is, but there is a comfort in the disconnect—as if we drifted apart and secluded ourselves from the mainland by choice.

Yet all this independence would be somewhat unnerving without the security of the Chappy ferry. Our relationship to the ferry is almost filial—she the mother to our needs. We are as dependent on it as we were our moms when we were small. We can go only so far without enlisting her help. She picks us up and brings us home. Always gracious, but a bit of the martyr in her, too. We trust in the benevolent competence of the ferry and her captains, just as we trust our mothers.

We take the ferry in inclement weather, rarely doubting that the trip will be anything but fine. She is the conduit to comfort—the audible sigh of relief. We set adrift on her, detached from the troubles that fade behind us during the three-minute trip—the other side never out of sight, but its details faded.

The ferry is our Manhattan lobby and elevator, our coffee shop on the corner—that brief get-together spot. She is also our bridge. I imagine the ferry as one length of bridge, laid one after another to its destination, like two planks over river rocks.

I love sitting on her high-gloss enamel seats, amid her motherly collection of dos and don'ts signs. Night or day, I ease into place between her rails and sigh that happy breath of someone who is returning home. Thanks, ferry. Thanks, Mom.

—B.W.

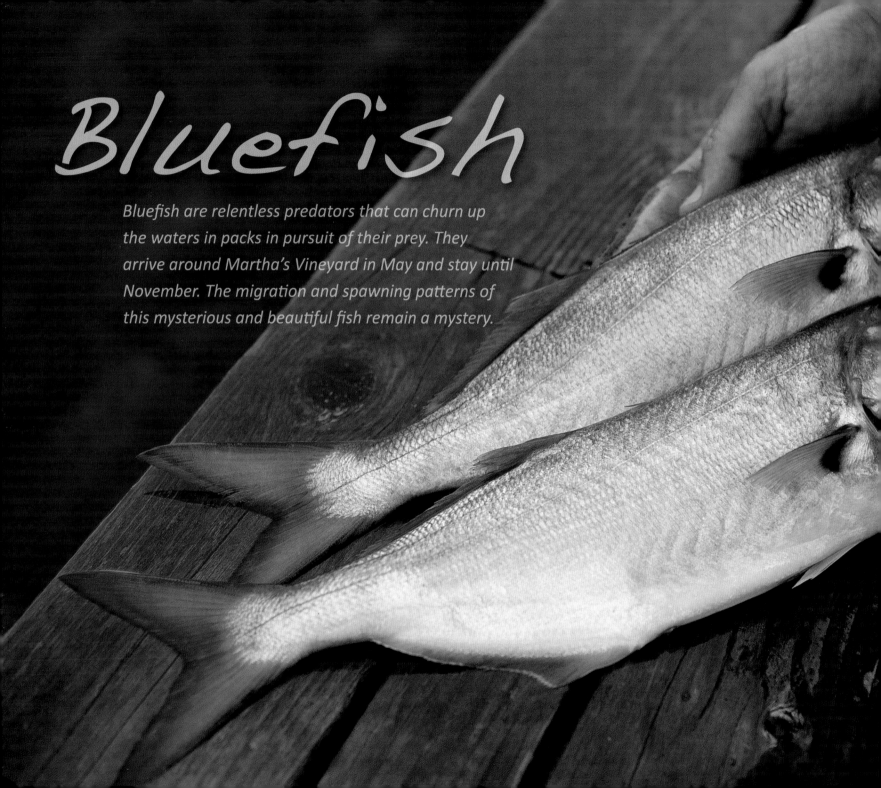

Bluefish

Bluefish are relentless predators that can churn up the waters in packs in pursuit of their prey. They arrive around Martha's Vineyard in May and stay until November. The migration and spawning patterns of this mysterious and beautiful fish remain a mystery.

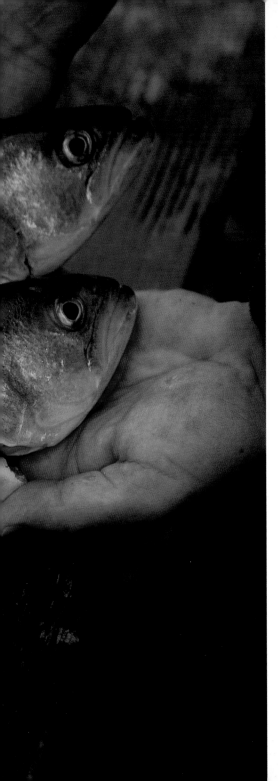

You may think you know bluefish: oily, fishy, in need of lots of mayonnaise to camouflage it. But we challenge that conventional wisdom.

When bluefish is treated properly it is the most flavorful, versatile fish available. Our kids always preferred it. We've tried many different ways to prepare bluefish, and just about every method has been successful, as long as, and this is important, the blood is drained from the fish at the time of the catch.

Bluefish are voracious eaters. A frenzy occurs when they round up a school of baitfish and become eating machines. They gorge themselves, and you'll often see baitfish being spit out as the blue is reeled in. Giant bass are sometimes caught in the wake of a bluefish frenzy when they come in and feed off the leftovers.

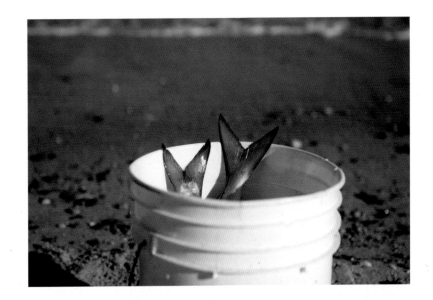

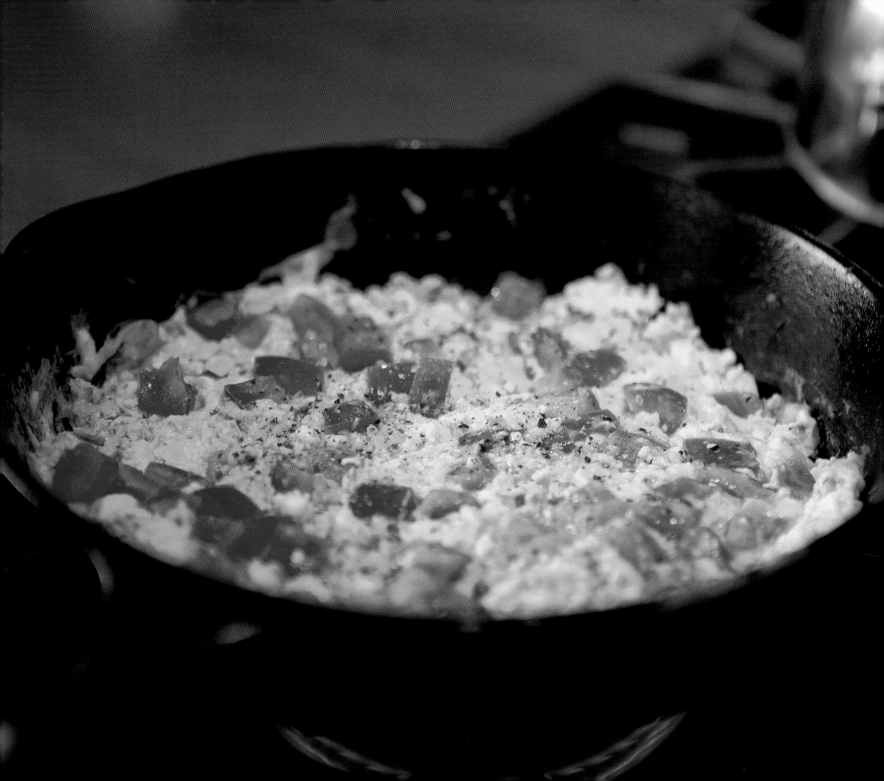

Bluefish Hash (or Bluefish Frittata)

This recipe has evolved over the years. Jeff and our sons, Jack and Nick, would bring in the early-morning catch, and they would be in need of a hearty breakfast. We've tried it with striped bass, but the more flavorful bluefish remains our favorite.

What you need:

1 tablespoon butter

3–5 chunks bluefish

3–4 eggs

Handful chopped green peppers

1–2 tomatoes, diced

Salt and pepper

1 cup Mozzarella cheese (optional)

Melt butter in a cast-iron skillet or saucepan.

Place the bluefish in the pan, skin side down. Cover the pan and cook at high temperature for 3 or 4 minutes.

Chop up the fish and skin with a spatula. (The skin is rich in protein.)

Reduce heat to medium and add 3 or 4 eggs (an egg per person).

Mix eggs and fish and season with salt and pepper. Add green peppers and tomatoes and mix together.

Cook at medium heat for 3–5 minutes. Sprinkle cheese on top. Turn off heat and let sit for 2–3 minutes before serving. The bottom will be crusty.

Cut pie-shaped servings and serve along with whole-wheat toast and a large pot of coffee.

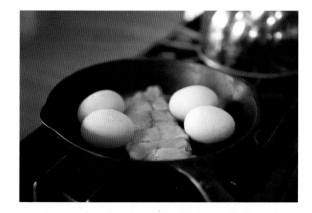
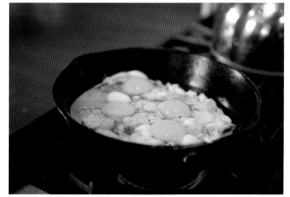

Chappy doesn't ask a lot from us. Stay out of her poison ivy and ticks, and we're good. But she gives us a lot in return. More than one soul has been healed on a cool summer night.

—B.W.

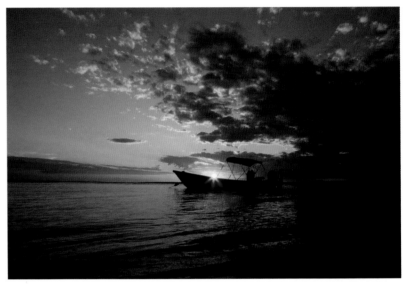

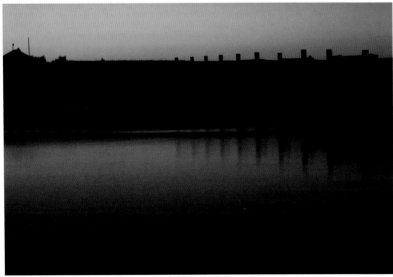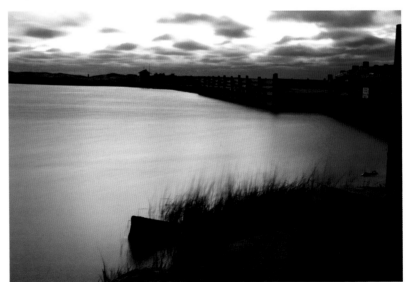

The ubiquitous Chappy summer sand. Hitching rides on wind, feet, hair—it finds us. Our constant companion. Loyal partner in all we do—sleep, eat, work, drive, play. It hunkers down in the corners of window sills, between insole and shoe, and folds of the ear. It fills the gaps in floorboards and rug fibers. Taken from home, it searches out new homes—places to rest and settle.

It smells different when wet. Or on a dog. Or on the beach. It takes on the essence of its host, a poor camouflage to its gritty existence.

I like the sand. Its attitude. I like the way sand looks in the bottom of a foot wash, outside a door, and on a concrete floor. Content to settle out to the bottom of anything—it reminds us to rest and be at home wherever we may land.

—B.W.

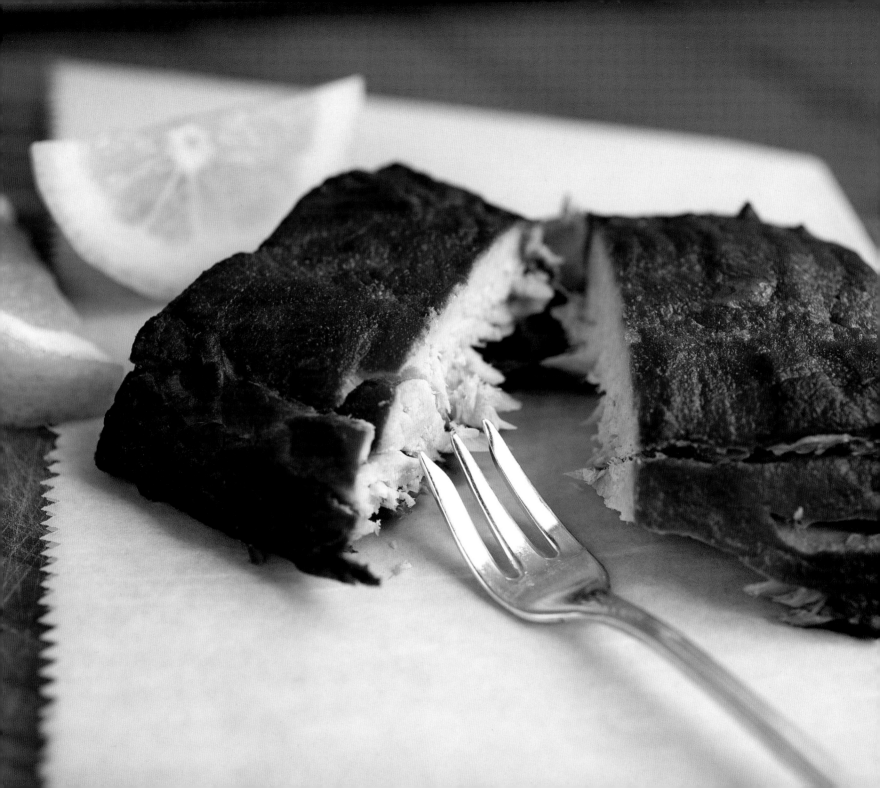

Smoked Bluefish

For years we'd been buying delicious smoked bluefish. Then one day my husband said, "We bring in so much bluefish, why aren't we making this ourselves?" I gave Jeff a Green Egg cooker, and he took cooking on the grill to a whole new level. The Green Egg is a clay pot that can heat up to 650 degrees, and it will hold temperatures for hours. It is extremely versatile for grilling, smoking, and roasting.

What you need:
Bluefish fillets
2 cups hickory chips, soaked in water for 2 hours
Sea salt
Lemon

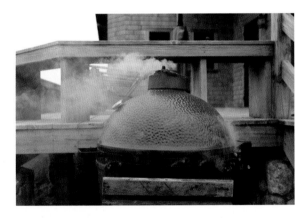

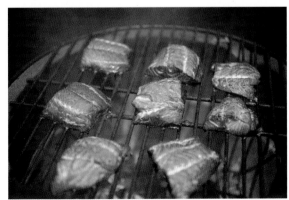

Cut your bluefish into 4- or 5-inch fillets and place them in a large pan. Cover with water and generously pour a few tablespoons of sea salt over all of them. Set aside for 2 hours.

During this time, soak your hickory chips.

Set your charcoal grill and wait half an hour until the coals are red. Close the top and close down the air vents and let temperature reach 350 degrees.

Drain water from the wood chips and sprinkle them over the hot coals. Place fillets on the grill, skin-side down.

Close the cover to the grill and let temperature reach 250–300 degrees.

Cook for 1½ to 2 hours.

Remove fillets, cool, and store in a glass container in the refrigerator.

Squeeze fresh lemon over each when serving.

Birds (and Other Residents)

5:30 a.m., Sunday

The harbor is glass. The yacht lights reflect off the water like night lights in a mirror. No voices, no motors running, absolute quiet. Except for the birds.

And they are noisy. Like schoolchildren at morning recess, they shout and call to one another, flitting here and there, arguing a bit, and milling about the grounds. A lone cormorant sits quietly on our post, too goofy in his yoga pose to be aloof, but seemingly content to be alone and unengaged.

Finches (I call all small birds "finches") litter my lawn like barely animate pine cones. A robin couple stumbles about, hardly awake. The crows, of course, hop about and yell as if they own the place—which they do, being ten times the size of the finches and almost as numerous. The seagulls call to one another in those oddly human voices—overly emotional and dramatic in all their dealings. "Heyyyyyy—I saw that first! That's my crab!!!" "Is not!!" Each group of birds does its own thing, unbothered by the goings-on of the others. I'm sure there's a lesson there to be learned, but I just enjoy the spectacle.

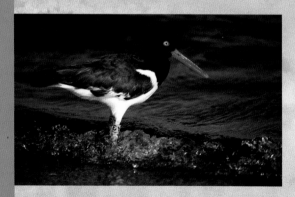
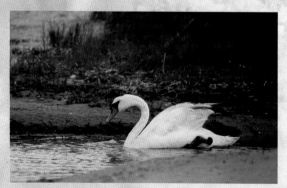
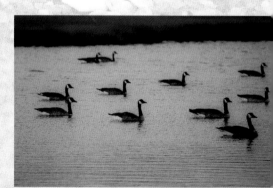

Later in the day, the birds will be joined by people, bunnies, dogs, and trucks. The crows, and the occasional hawks or osprey, will make themselves known with a piercing cry that makes me want to shout, "Shut up!" The crows will chatter nonstop, and seagulls continue to call out "Braaaaad!" What? Who? The singularity of their morning presence will be lost in the hubbub of day.

Later, much later, after even the crickets and peepers have retired, the night birds will be heard. Owls and whatever else I hear will chat with far less clamor and frequency than their morning brethren. Their chatter is more like the appearance of the rare lights of a passing jet overhead: unpredictable and uncommon.

But for now, the morning belongs to the birds.

I was in Alaska once on a cruise and saw only two birds—both ospreys—the entire time. Chappy is amazing. Simply amazing.

—B.W.

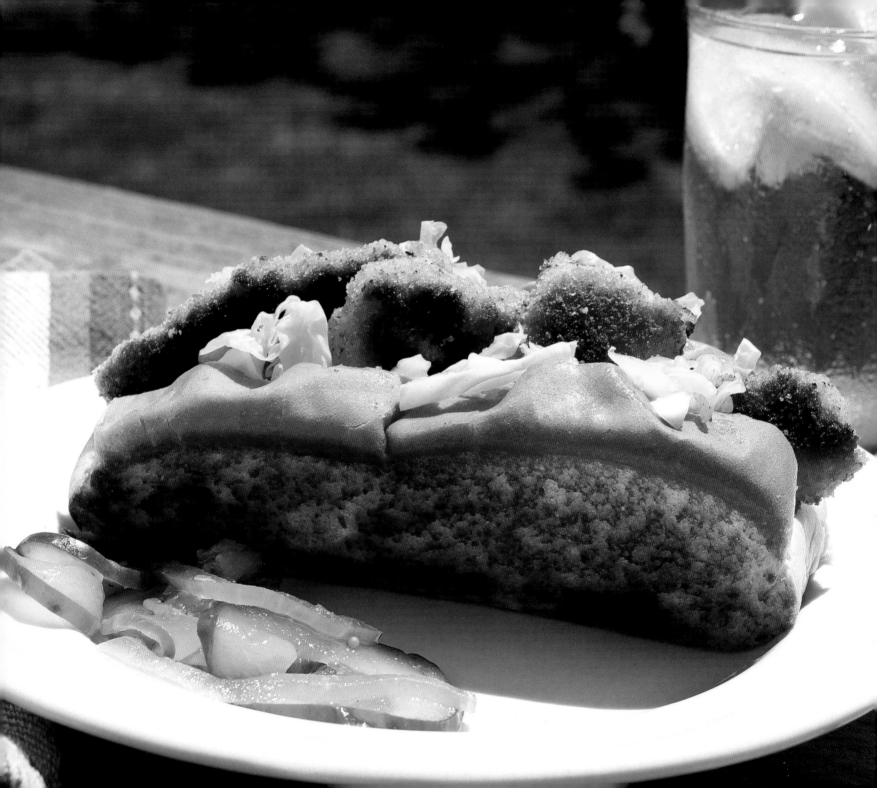

Blue Dogs

We can't get enough of bluefish. These melt in your mouth. My son said he could eat six of these at one sitting, so make plenty. Add a side of pickles and a Ballantine Ale.

What you need:
Butter
Hot dog buns
Cabbage or fennel
Juice from one lemon
Salt and pepper
Bluefish fillets, skinned (4–5 chunks for each roll)
Flour
1 whisked egg for dipping
Fine breadcrumbs (homemade breadcrumbs recipe on page 59)
Canola oil for frying

Butter the sides of hot dog rolls and grill them in a cast-iron pan.

Shred enough cabbage or fennel into a bowl for the number of people you are serving. Sprinkle with lemon and salt and pepper. Make a bed of this slaw in each hot dog roll.

Cut bluefish fillets into 2-inch chunks, using white fish and discarding the dark meat. Figure on 4–5 chunks per roll.

Dip each piece first in flour, then whisked egg, and finally fine breadcrumbs.

Heat canola oil in cast-iron pan and cook fish chunks 1–2 minutes on each side.

Place fish chunks in each prepared roll.

SUVs

The rise in popularity of the sports utility vehicle changed a lot about island life.

There was a day when only a few four-wheel jeeps could be spotted on the beaches of Chappaquiddick. Most people used to pack up a station wagon, park in a designated parking lot, and then haul the kids and the gear to the best spot that was within reasonable walking distance. SUVs gave everyone the freedom to take a fully packed car and drive right to those spots in the distance.

The fishing grounds at Wasque Point and the "Gut" at the end of the island are two of those distant spots, and they became like playgrounds to fishermen and their families. Dozens of trucks congregate for the best fishing on the island, if not the East Coast. Trucks pull up, kids tumble out, and the day begins.

Over the years we collected a big pack of friends on those beaches. We'd line up our vehicles or circle them like the old wagon trains on the open plains.

The summer days we shared with friends were long and full. There were football games, Wiffle ball games, drama shows, wrestling matches, and all the while the fishermen had their rods lined up on the beach with their tackle boxes opened up and ready to go. They kept a constant eye on the water, watching the birds, the tides, the current, and looking for any bend in a rod to signal that the fish were there.

We'd stay in our spots all day. We'd wait for the golden hour when the sun wrapped us all in the warm light. Then we'd break down camp, pack it all up, and a caravan of cars would head home for the night. Kids' voices streaming out the windows, radios playing, everything a little more subdued. Sun-baked, salty, and content.

A familiar sound that also says summer to us is the hum overhead of the World War II biplane we call the "Red Baron." There are a few of these classic planes at the nearby Katama Airfield, and veteran pilots offer spectacular tours of the island throughout the summer months. We never tire of hearing their distinct sound and the sight of them flying low over the beach and bay. And even better, we always hope we'll see them show off their skills with a loop-the-loop. We took the kids for a ride years ago, and pilot Mike Creato was proud to say his coffee never spilled a drop when he performed a stunt.

Bluefish-Stuffed Grape Leaves

Cascading grape leaves are everywhere on the island. Legend has it that in the 1620s English explorer Bartholomew Gosnold noticed the abundance of grapes and named Martha's Vineyard for his daughter. In the early summer I often stop and pick dozens of the tender young leaves to make these stuffed grape leaves.

This recipe was inspired by our friends Mary and Joe Najmy's Lebanese family recipe. Jeff and I are always trying to use the resources around us in different ways, and somehow the idea came to me to try adding bluefish to the mix. These have become a family favorite. They are full of flavor.

Recipe for the fish stock is on page 113.

What you need:
2 dozen freshly picked grape leaves
1 cup cooked white rice
Handful of pine nuts
Dash of allspice
½ cup chopped sweet onion
1 minced garlic clove, plus two or three more whole cloves
Chopped fresh basil
Juice from one lemon, plus two or three others for squeezing
1 teaspoon sea salt
Shredded bluefish

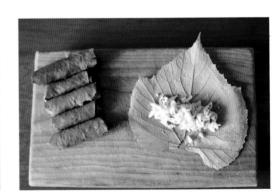

Using young, light green grape leaves, remove the stems and soak the leaves in a pan of warm water for half an hour.

While the grape leaves are soaking, cook white rice per instructions and let cool.

In a large bowl combine pine nuts, allspice, onion, sea salt, rice, and a cup or so of uncooked, shredded bluefish. Add the minced garlic clove, chopped fresh basil to taste, and the prepared lemon juice.

Take each grape leaf out of the water and pat dry.

On your work space, arrange the leaves pale side up. Spoon tablespoons of the rice and fish mixture onto the center of the leaf. Take the right and left sides of the leaf and fold them in over the rice mixture. Take the bottom side of the leaf and roll it over the rice, holding the sides as you go and keeping it as tight as you can. (This takes a little practice. Think of it like wrapping a present.)

Place as many leaves as you can fit into a Le Creuset–type pot. Squeeze lemons over the whole thing. Add enough fish stock to go to just the top of the leaves, laying a plate gently over the leaves to hold them in place. Toss in two or three whole garlic cloves and cover.

Steam on the stovetop for ½ hour. Occasionally check the water level to make sure that the leaves stay partially covered.

Remove grape leaves with a slotted spoon and enjoy either warm or chilled.

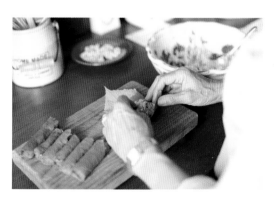
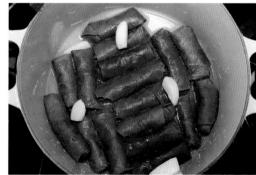
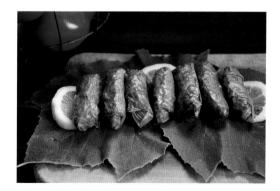

Treating the Fish

The key to great bluefish is to tend to it from the moment it is caught.

Jeff puts a knife through the gills, cutting the main artery but being careful not to touch the spine. The fish then goes head first into a bucket of fresh sea water while most of the blood drains out of its system. Within fifteen minutes the fish is cut into fillets and put into plastic bags and onto ice in a cooler, which he always has with him. The carcass is thrown back into the ocean.

Bleeding bluefish, as well as bonito, keeps the oils from the blood from seeping into the meat, spoiling the flavor and changing the light color of the meat to the purplish blue color you're probably used to seeing in a lot of markets. Striped bass do not need to be treated in this fashion.

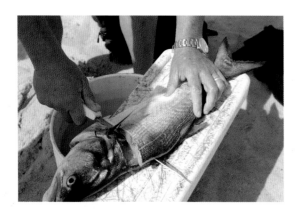

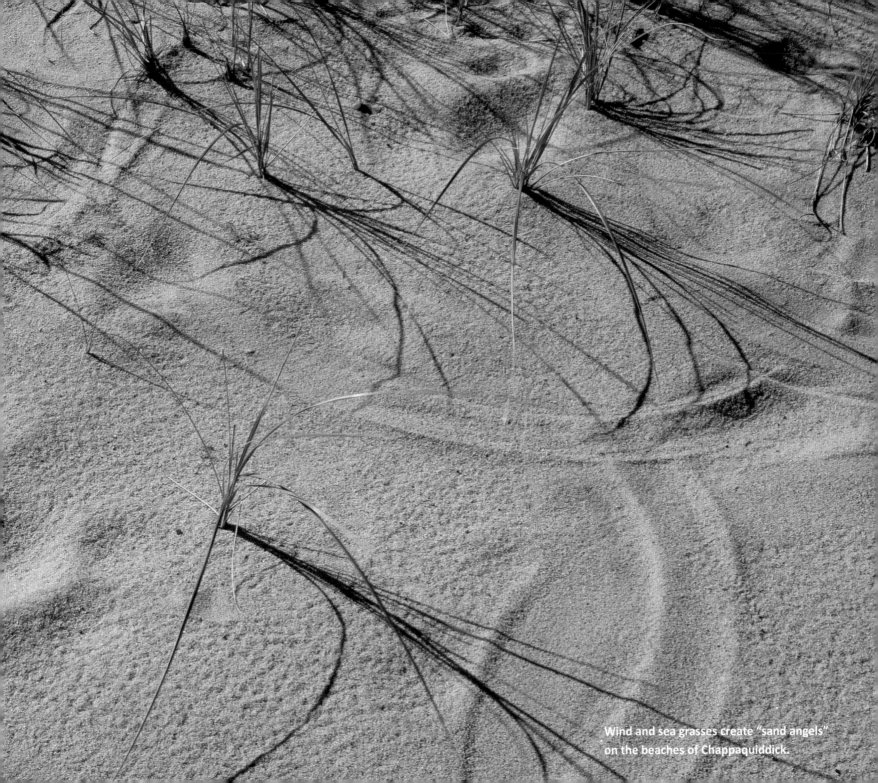

Wind and sea grasses create "sand angels" on the beaches of Chappaquiddick.

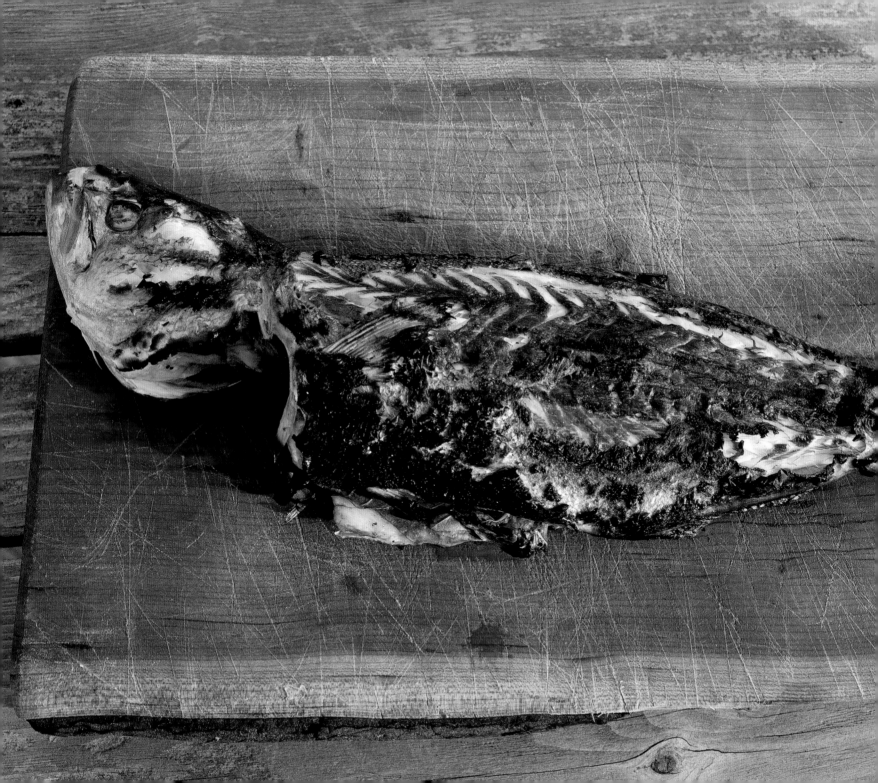

Whole Grilled Bluefish

It's not often you pull in a 1½-pound bluefish. If you do, it's a keeper! Scale it, gut it, and cook it whole on the grill! Serve with tomato and basil relish and salad with vinaigrette for an absolute feast.

What you need:
Bluefish
Basil leaves
Chunks of butter
Olive oil

If you have a Green Egg grill, heat it up to 600 or 650 degrees. Otherwise, heat your grill as high as it will go (hopefully to 500 degrees). Stuff the belly with whole fresh basil leaves and chunks of butter. Rub olive oil on the skin.

Place whole fish on the grill. Cook 5–6 minutes a side, at 600 or 650 degrees, for a fish that's 1½ inches thick.

Lay the cooked fish on its side on a platter and let sit for 5–10 minutes so that the juices soak into the fish meat. Carefully peel skin away from the meat with a spatula. Serve the fish in chunks or take your knife and make an incision down the middle of the side of the fish, from its gill to its tail. Slip your knife into the meat until you feel the spine, and then, while keeping your knife between the meat and the spine, gently fold over the meat to the right and left sides. You'll see that the spine is fully exposed so you can peel it out of the body. The entire fish can now be served easily with a serving fork and knife.

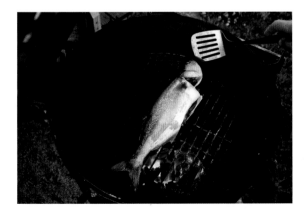

My Husband, the Fisherman

My husband is a really good fisherman. He wouldn't want me to call him a great fisherman because there are a number of them on Martha's Vineyard, and he knows who they are. He is good enough, though, to bring home a fish to eat almost every day.

He has a keen sense of where the fish are. He studies the tide charts, he considers the temperature of the water, and he knows the inlets and narrows of this island. I tease him that all he has to do is put his nose to the wind and follow the scent to find the fishing spots.

"It is not down in any map; true places never are."

—Herman Melville

Gear

The fishing gear is a big part of the look and feel of our cottage. It's part of the furniture. It wouldn't be a fishing camp without the rods mounted on the wall, the waders hanging in a row, and the tackle box and reels stacked up and ready to go at a moment's notice.

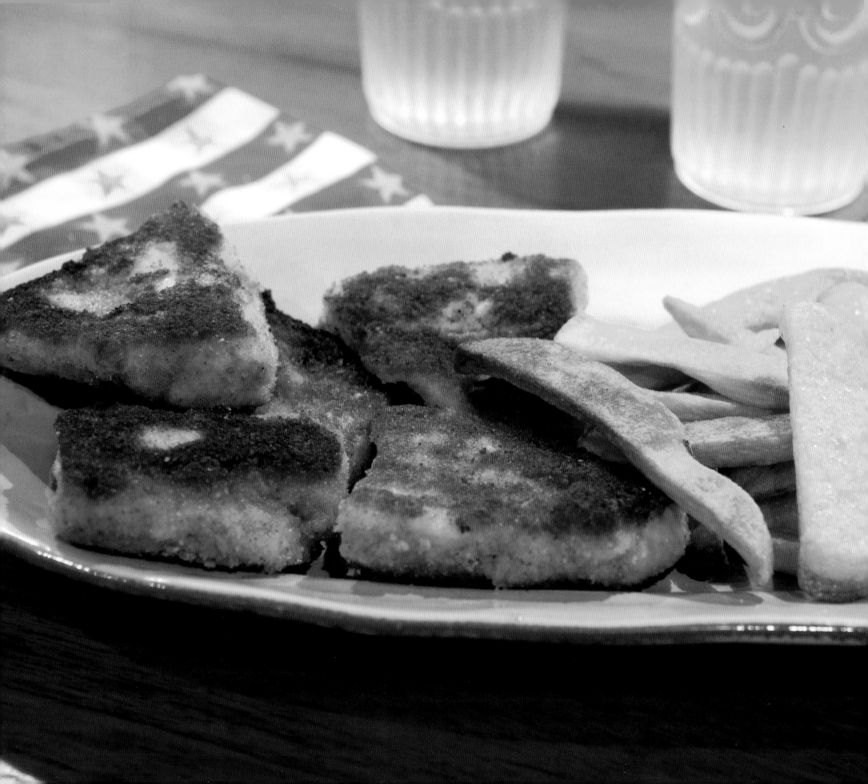

Bluefish & Chips

What you need:

Skinned bluefish fillets from 1 or 2 fish

Flour seasoned with salt, pepper, and any favorite herbs. (I like to add a teaspoon of By the Sea Salt, a salt and herb mixture made on Martha's Vineyard.)

1–2 eggs, beaten

1 cup fine breadcrumbs (homemade breadcrumbs recipe on page 59)

2 tablespoons canola oil

Cider vinegar

Cut the bluefish fillets into 3- to 4-inch pieces.

Heat the canola oil in a large cast-iron pan.

Dunk each piece into the flour, the egg, and the breadcrumbs.

Cook the pieces 3–4 minutes a side.

Serve with french fries and some vinegar to sprinkle over both.

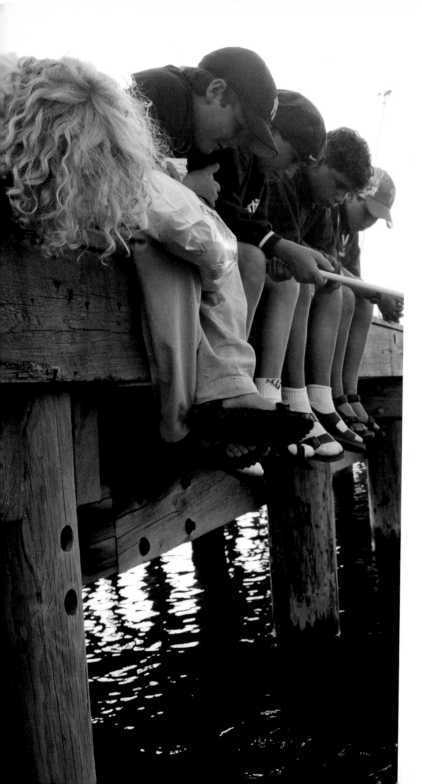

We Used to Wait

There was a joy in slowing down. We'd come to Chappy, away from the ringing of home phones to quiet island phones. If the phone rang at my grammy's, someone wanted a ride home or a drink on the porch. Now the ringing (in all its mutations) follows us here. Distance is no longer enough to discourage attachment. The sea does little to abate the connection to that which we leave behind (flee?).

Waiting has become a lost art. We are now almost always accessible. But if not, on those rare instances when we are out of range, we have forgotten how to occupy ourselves, simply to be alone.

Yet, despite the world's insistence, Chappy does afford opportunities for patience. I wait for most everything here. I wait for the grass to grow, for the grass to stop growing, for the rain, for the sun, for the fungus to abate, for the soil to aerate, for the crows to quiet, for the whippoorwill to sing, for the tide to come in, then go out. And as long as I'm willing to wait—to accept the order of a plan that far preceded mine—the chaos is manageable.

Chappy is chaos because Chappy is natural. And anyone who has attempted to apply order to nature knows the attempt to be

futile. Don't want flying ant parts falling from your ceiling? Moss growing on loafer insoles? Mice in your rolled-up rugs? Too bad. Nature and Chappy will always win, because behind each resolution is a new issue. That is, at least, until one accepts the order of disorder. That acceptance, that letting go, is what allows one to wait. Wait for the mice to pack up and move; for the season to change; for the bugs to cycle into another, less prominent, state of being.

I love Chappy. I love its chaos. Its order. Its cell phone dead spots. I love that Chappy will embrace and protect me if I'm simply willing to offer it the same kindness.

—B.W.

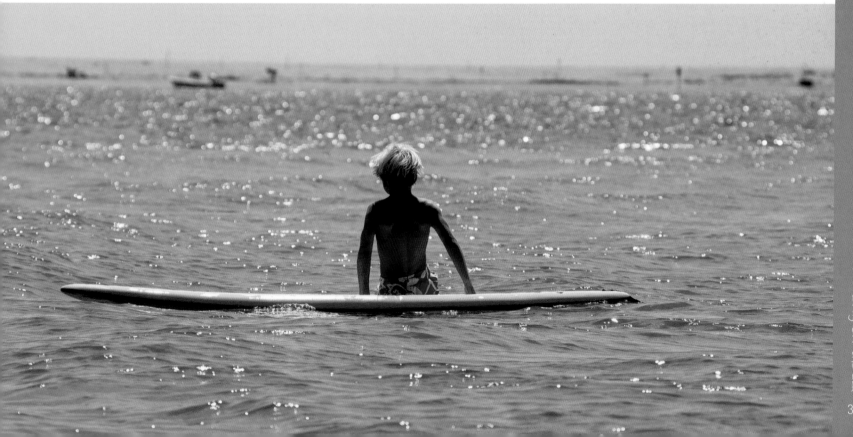

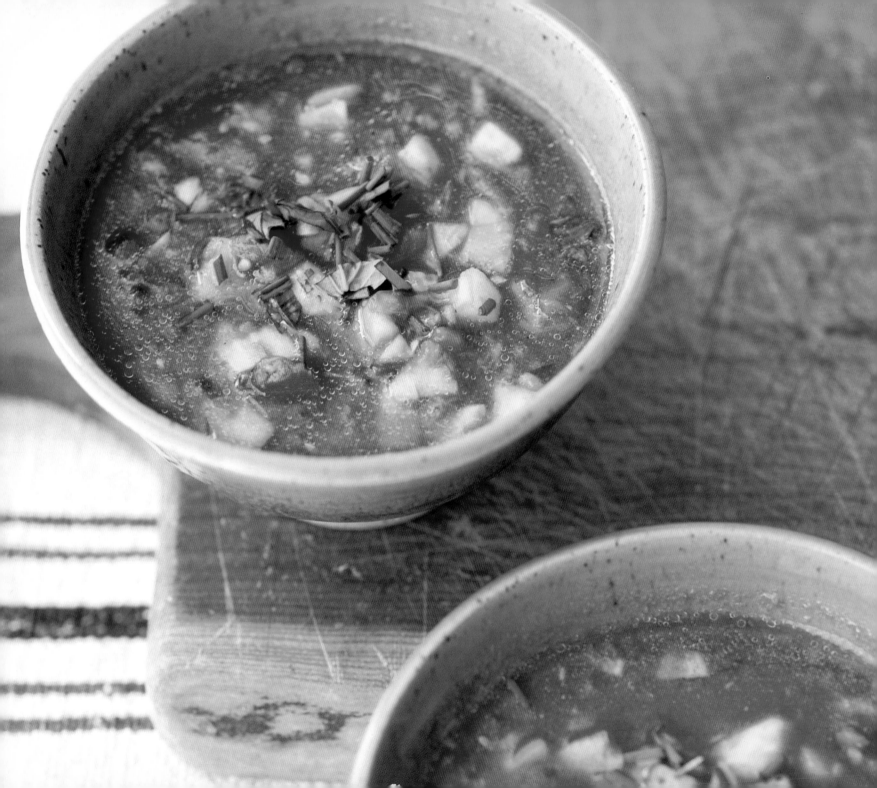

Gazpacho

There are many variations on this cold summer soup. You can add different fresh vegetables, so this recipe can be used as a starting point.

What you need:

5–6 large fresh tomatoes, peeled

1 cucumber

1 fresh onion

1 sweet green pepper

2 tablespoons wine vinegar

3–4 tablespoons good-quality olive oil

1 pressed garlic clove

1 teaspoon sea salt

Fresh ground pepper

Pinch of cayenne

1 teaspoon each: chopped parsley, basil, and mint

Optional: Avocado or plain yogurt

Chop all the vegetables in a large wooden salad bowl. Add remaining ingredients and mix together.

Transfer to a storage bowl and chill in refrigerator until it's time to serve.

Garnish with chopped chives and basil, or chopped avocado, or a dollop of plain yogurt.

To add variety, I've mixed this in the blender for a second-day serving.

Feasts and Frenzies

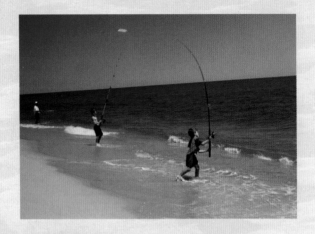

There are very few things that I can say I'm good at with confidence. Spotting a bluefish frenzy is one of those things. It's a skill that I developed over the course of my childhood, combing the desolate beaches of Chappaquiddick in the early morning sun.

There were always bumps in the tire tracks when my brother, my dad, and I arrived at the soft sand of East Beach, a sharp contrast from the serenity of the Dyke Bridge. I always wondered, and still wonder, how those bumps were formed. When we first drove over them, they threw us out of our seats. The coffee spilled, we hit our heads, and the rods rattled against each other on the roof. Bracing ourselves, we passed over the dunes and arrived at the long stretch of beach that led to Wasque Point. It wasn't until that moment that my eyes would truly open. We drove south, and the three of us looked to our left, in silence, at the glistening water and at the sun itself, still soft enough to allow us. The bumps in the sand became steady then, and methodical, like the waves.

This was the beginning of the hunt. The three of us looking left, scanning the horizon for the slightest disturbance. A flock of birds diving, the splash of a tail, an abnormal swirl. These were the things that we hoped for and the things that excited us. There was always the sense that somewhere on Chappy, within casting distance, there were fish and we would find them.

I cannot think of anything more thrilling to this day than that moment when my wandering eyes would halt and focus. A swarm of terns and splashes can be incredibly subtle from a distance, but once spotted, it materializes and broadens and becomes unavoidable. It was this sudden awareness of isolated chaos in nature that made our hearts beat faster, as well as the thought that our prey was close, and unabashed.

It was rarely more than a couple minutes from the time we spotted the frenzy to the time our lures were within striking distance. We knew how to reel for frenzies. Slightly frantic, but steady. Once you get a hit, don't stop reeling, but don't jerk too soon. Let them take it, then hook your fish confidently. Once you hook the fish, keep your tip up and get it in quick, before your line gets cut in the swarm. If the fish jumps, keep the line taut and hope for the best. Wait for a wave to bring it onto shore, and do it in one solid motion. Grip the fish confidently to take out the hook. Bleed it in a bucket full of salt water before filleting. Then relax with the smell of blood on your fingers while you enjoy a soda, and then years later a beer, and then eventually a cigar.

When the sun grows too hot, bring home the fillets to the women and children. And later on, when the sun fades below the horizon, look down at the feast that you provided, and think about that moment when you spotted the small disturbance in the distance.

—Nick Fager

Raising kids in a fishing culture gave them the chance to master skills while they thought they were just having fun. They learned the discipline of waking up with the tides, sometimes as early as 4 a.m. They learned the art of casting and which lures to use from their father. They met a varied group of fishermen on the beach, and they had to know the code for how far to stand from the next fisherman, and how to be a good sport when a fish was lost or a line broken. And above all they learned patience. Sometimes it took awhile, sometimes it didn't happen, but it was always time well spent.

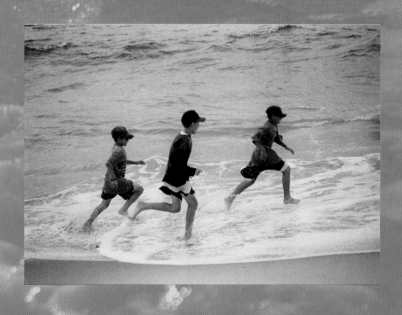

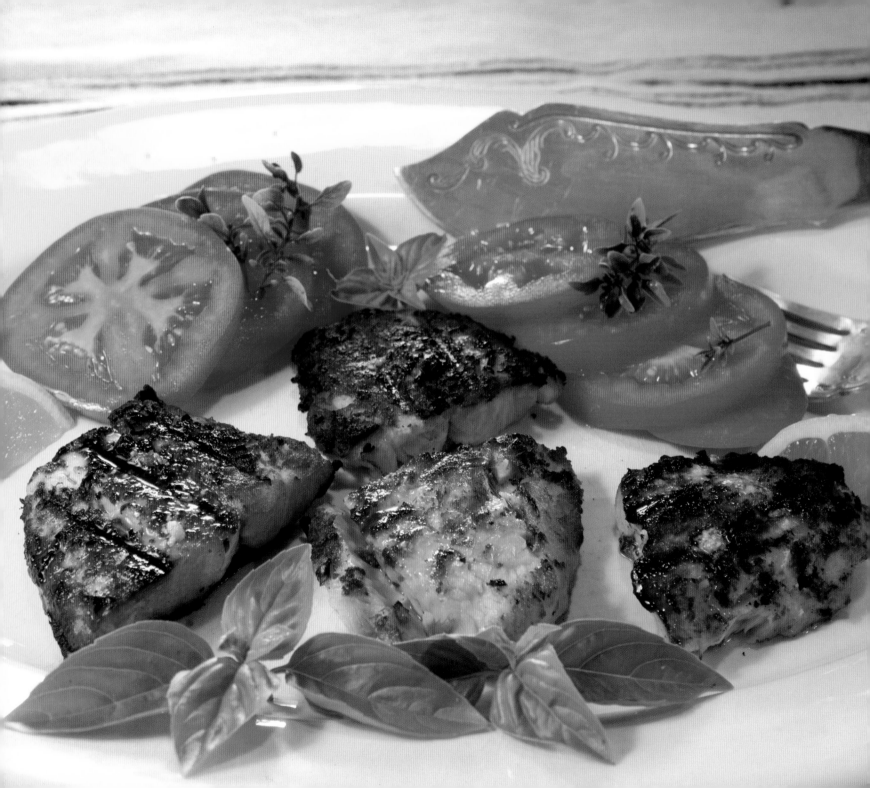

Grilled Bluefish Fillets

This is our favorite way to cook bluefish. The times vary depending on the thickness of your fish. This recipe is for 1½-inch fillets.

What you need:
Fillets to fit number at your table
Fish marinade (see page 45)

Place the fillets in a shallow pan. Cover them with the marinade (see page 45). Cover with foil and place in refrigerator for an hour.

Heat grill to 500 or 600 degrees.

Place fillets skin side down. Cook for 4 minutes with grill covered. Flip the fillet by slipping a metal spatula in between the fish meat and the skin, gently flipping each one onto a clean spot on the grill.

Cook fillets for another 4 minutes.

Spoon leftover marinade to melt over each fillet.

Leave the skin on the grill to cook a little longer. (My brother-in-law calls it bacon. It's crispy and delicious.)

Serve with melted butter and lemon wedges and a toss of coarse sea salt.

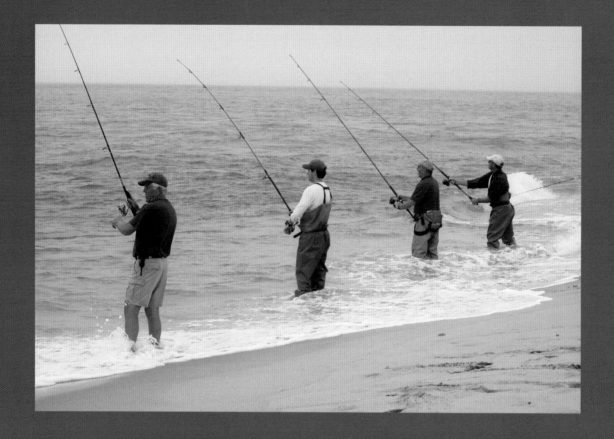

Bluefish Compression Syndrome

Jeff and his longtime friend and fishing buddy, also Jeff, came up with a term—"Bluefish Compression Syndrome"—to explain a strange fishing phenomenon. They would be fishing together, looking at miles of open beach shore, without another soul to be seen. When the fish start to come in, a friend they haven't seen all summer is suddenly fishing within six feet of them. Within minutes there can be fifteen fishermen within fifty feet of each other. When they're all good surfcasters, lines don't usually get crossed. But when it happens, it can be a challenge. Either way, they always end up seeing old friends and making new ones.

Fish Marinade

This is my basic marinade for bluefish, bonito, and striped bass, and it can extend to almost any fish you have available. I tend not to use as much basil with striped bass, so that I don't take away from its subtle flavor.

What you need:
2–3 tablespoons butter
1 teaspoon Dijon mustard
Juice of 1 lemon
1 garlic clove, minced
Salt and pepper
1–2 tablespoons chopped basil leaves

Melt butter in saucepan and add all other ingredients.

Spoon this mixture over fish fillets that have been placed skin side down on a platter.

Refrigerate for an hour.

Near the end of cooking the fish, either on the grill or on the stove, use the leftover marinade to top off your fish.

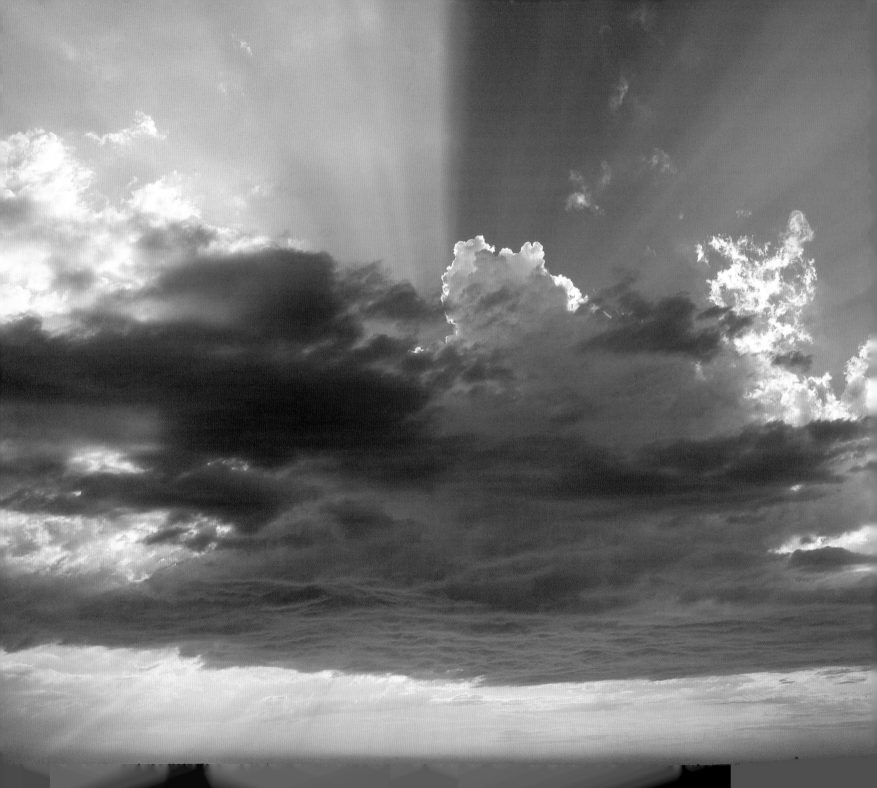

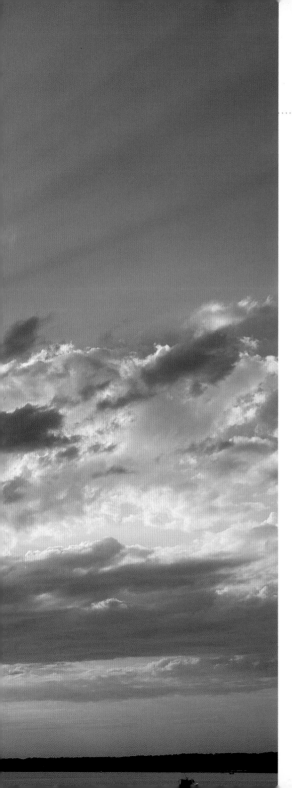

Rum Punch

A Rum Punch and island life go together well. Here's our recipe. Enjoy with a plateful of oysters on the half shell. Nothing better.

What you need:
1 shot (ounce and a half) Mount Gay Rum
Half cranberry, half orange juice mixture
Bitters
Myers Rum
Fresh nutmeg, to grind over the drink
Soda water (optional)

Fill an old-fashioned glass with ice. Add shot of rum, then juices. Add several drops of bitters. Top off with a splash of Myers and sprinkle with fresh nutmeg.

To make it less potent, add soda water.

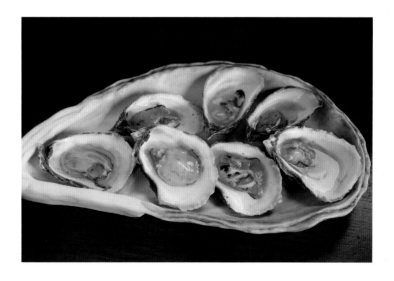

Can't Get There from Here

There are markers on Chappy, real landmarks that denote location, which are fine if the location that you're describing is within ten yards of that landmark. Any farther and you must rely on the ever-changing mailbox or disappearing street post. And if the roads or driveways are marked, who here remembers their names? I've been here going on forty-nine years, and I cannot name more than four of the roads on Chappy.

Okay, three.

Two.

Adding to this confusion is that distance seems relative to Chappy folk. One person's mile may be another person's three miles. For those odometer watchers among us, we are doomed to find ourselves outside a chicken coop near Poucha Pond.

Trust me.

Oh, but what of the wonders of GPS mapping systems? Who needs directions when you have Google Maps?

Everyone on Chappy, that's who. True, you may be able to navigate the first straight mile of Chappy Road, but navigation becomes more difficult elsewhere when the on-board GPS can be heard to sob with doubt and frustration. Even with satellite assistance, you can still find yourself driving though somebody's yard, then field—believing that at any moment the GPS will be vindicated, and North Neck Road will appear like Valhalla before you.

There may have been a day when it was easier, and more fruitful, to give directions on Chappy. A day when people listened. Now, we are inveterate nonlisteners. We can only accept information in twenty-second bites. Beyond that, our brains have moved on.

Now imagine giving these directions to someone, and having them actually listen: "Take the ferry from Edgartown to Chappy. Don't know where that is? Ask someone in Edgartown. Then get off the ferry. Yes, you need to get off the ferry. Then drive about six-tenths of a mile to a dirt road on your right. You'll pass the Beach Club on your left, and a pond on your right. The Beach Club? You'll recognize it. You just will. Fine, it has red, white, and blue hats on its cabanas. Cabanas? They're like little houses. Turn right onto that dirt road. It's called Litchfield Road, but I can't remember if the sign is still there, then go past maybe a dozen mailboxes . . . maybe more, maybe less, and turn left on either the second, third, or fourth road you come to. . . ."

The eyes have long since glazed over or the pencil dropped on the phone's other end.

—B.W.

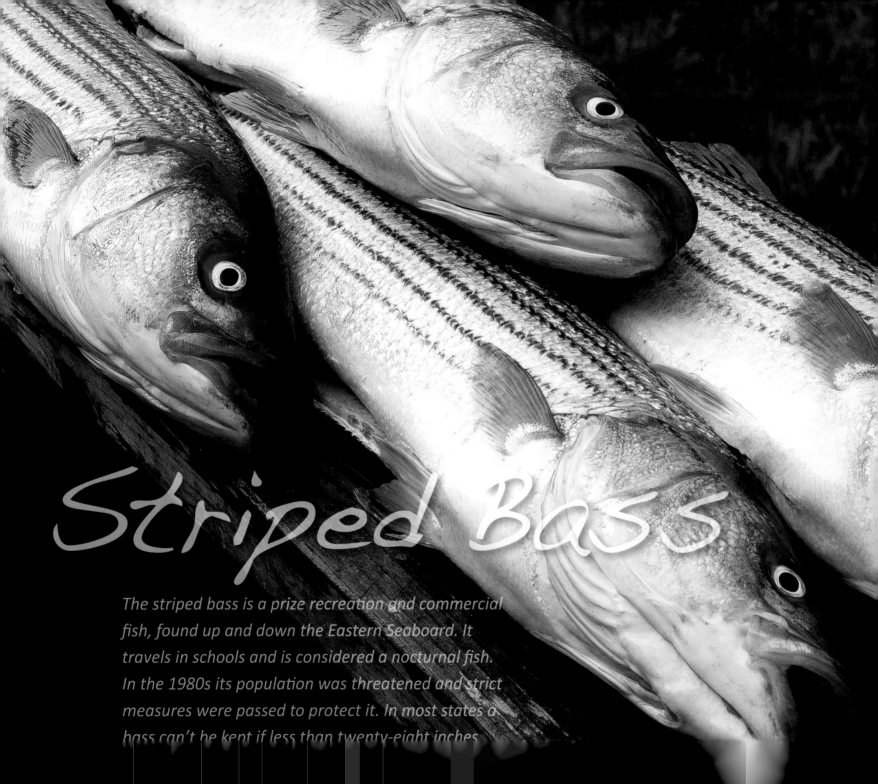

Striped Bass

The striped bass is a prize recreation and commercial
fish, found up and down the Eastern Seaboard. It
travels in schools and is considered a nocturnal fish.
In the 1980s its population was threatened and strict
measures were passed to protect it. In most states a
bass can't be kept if less than twenty-eight inches

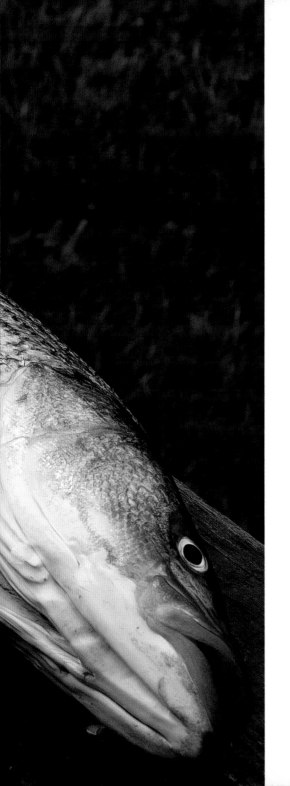

The striped bass is considered to be the noblest fish in our waters—and for good reason. It's strong, handsome, and elusive. To bring home a trophy striped bass is considered to be the greatest prize of all. Plans for a small dinner for four can suddenly turn into a feast for ten or twenty when a big bass is caught.

The striped bass population was almost depleted in the second half of the twentieth century. The fish was put off limits for years and then strict rules were implemented to regulate the size and quantity of the fish caught. Stripers are now one of the only successful fish recovery stories in the history of the Eastern Seaboard.

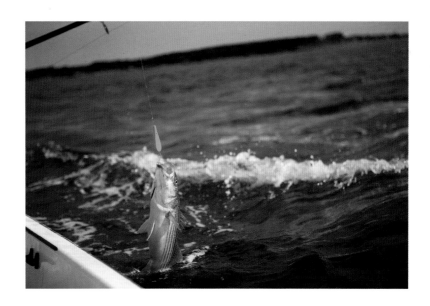

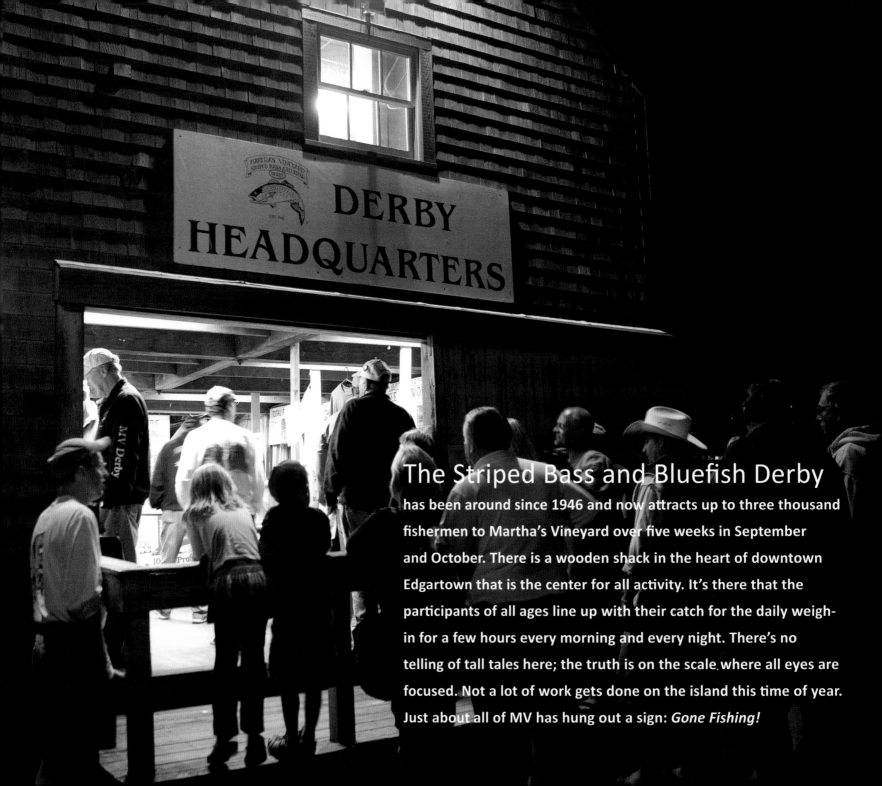

The Striped Bass and Bluefish Derby

has been around since 1946 and now attracts up to three thousand fishermen to Martha's Vineyard over five weeks in September and October. There is a wooden shack in the heart of downtown Edgartown that is the center for all activity. It's there that the participants of all ages line up with their catch for the daily weigh-in for a few hours every morning and every night. There's no telling of tall tales here; the truth is on the scale where all eyes are focused. Not a lot of work gets done on the island this time of year. Just about all of MV has hung out a sign: *Gone Fishing!*

Striped Bass Ceviche

Striped bass meat is so pure and beautiful that you can eat raw chunks of it as it's being filleted. We also like to serve it as ceviche.

What you need:
Striped bass fillets
Juice from 1 or 2 limes
Sea salt

If you're filleting a freshly caught striped bass, cut out the part of the fish closest to the spine and slice into 1-inch slivers. If you're buying a fresh bass, you can cut some slivers off the fillets themselves.

Set in a baking dish, and squeeze the juice from 1 or 2 limes and add a little sea salt.

The lime "cooks" the fish in a few minutes, so serve immediately.

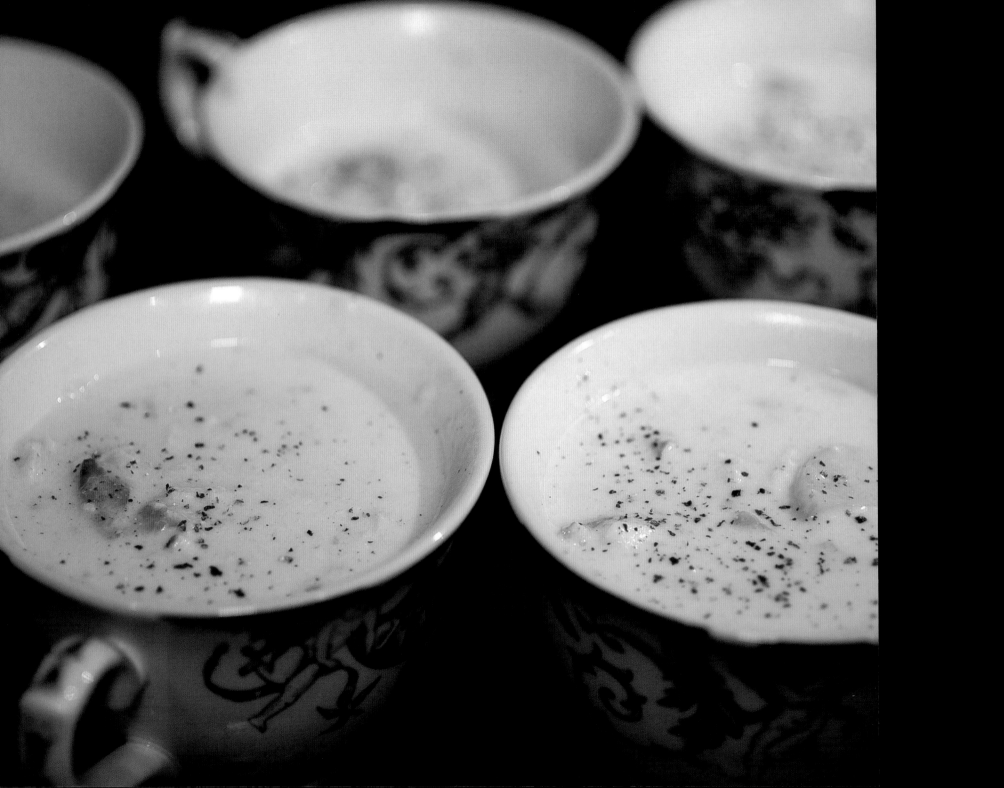

Seafood Chowder

Seafood chowder is like a declaration: Let summer begin! The first batch goes into the works only when there's an abundance of bluefish and striped bass. Spines of one or two striped bass are required to cook up a rich, flavorful stock, which is the base of the chowder. Add generous portions of chunked bluefish and bass, and add whatever else is fresh that day—cherrystones, local oysters, and a chicken lobster.

The chowder tastes best on a foggy day when there's a dampness in the air and a fire in the woodstove. And it's even better on the second day when all the flavors have had more time to cure.

What you need:

4–5 strips of smoked bacon
1 chopped Vidalia onion
½ cup flour
Fish stock (see page 113)
3–4 diced small skin-on red and
 white potatoes, or 6–8 fingerlings
6 cherrystone clams, scrubbed

1 chicken lobster
2 cups bluefish and bass chunks
1 pint whole milk or half-and-half
1 pint high-quality light cream
Green Tabasco sauce
Salt and pepper to taste

In a large metal pot, cook the smoked bacon and onion. Remove the bacon after onions are translucent, leaving the bacon fat and onions.

Make a roux of ½ cup flour mixed with cold water, and add to the bacon fat. Stir as you slowly heat the mixture.

Add 5–6 large ladles of fresh fish stock and the potatoes. Add cherrystone clams and bring the mixture to a boil. Reduce heat and let the mixture simmer for 5 minutes or so, until the clams open and the potatoes are tender. Remove the shells once they have opened (but leaving behind the clam meat).

Meanwhile, steam a chicken lobster (which is just a small lobster) in a separate pan in a very small amount of water for approximately 10 minutes, depending on the size. Shell the meat and chop up the amount you want to add. Lobster meat is very rich. With a small lobster I add both claws and the whole tail. If it's a bigger lobster I may only add the claws.

Add the chunks of fish to the mixture and cook for 2 minutes.

Add whole milk or half-and-half to the mixture. Add Tabasco sauce and salt and pepper to taste. Simmer for 30 minutes, stirring occasionally.

If you're not eating the chowder right away, store it in the refrigerator. Right before serving, add another pint of best-quality light cream and slowly heat the chowder to a simmer for half an hour, being careful not to boil. Serve with fresh pepper and sea salt.

A Fishing Affair

Is there a more intimate relationship than that between man and fish? A more tactile, visceral, and immediate connection between two beings?

Very few efforts in life provide such a complete bond between struggle and reward. Picking and eating a berry is one thing; catching and eating a fish another. The same is true in a different sense for those challenges undertaken purely for sport, and those that feed oneself. A long, grueling tennis match may satisfy the id and ego—but cooking one's catch satisfies a whole lot more.

Perhaps this is why some people genuinely love fish—and I don't mean simply as a food. It is a one-sided love affair, true, but in the kingdom of all living things, there is a premium put on respect for life. A fish adored and eaten may be better off than one caught, injured, and released.

We don't catch a lot of things these days. I haven't run down an antelope in years. But we catch fish. And we hold them. And we eat them.

I think if we held everything before we ate it, we might be considerably more reverent and appreciative of our place in life, and the gift of each meal. Ask a fisherman. He'll tell you.

—B.W.

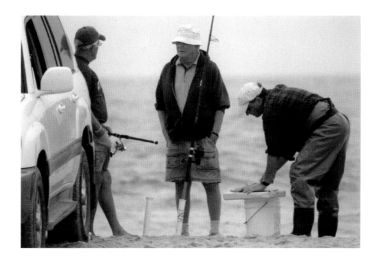

Fishing Comrades

The fisherman who congregate on Martha's Vineyard remind Jeff of the Moken, the nomadic sea gypsies who live off the coast of Thailand and Burma. When a powerful tsunami hit Southeast Asia in 2004, the Moken understood the sea and the patterns of the ocean so well that they knew to move to higher ground before the storm arrived.

The Chappy fishermen are also attuned to the weather and the tides. They know the best times to go out and the best times to stay home. They talk about the lures they used for the ones they caught and the ones that got away. Like the Moken, who don't have words for "hello" and "goodbye," these fishermen often don't bother with greetings and farewells. They just come and go. They know they'll see each other again, and they'll pick up the conversation where they left off.

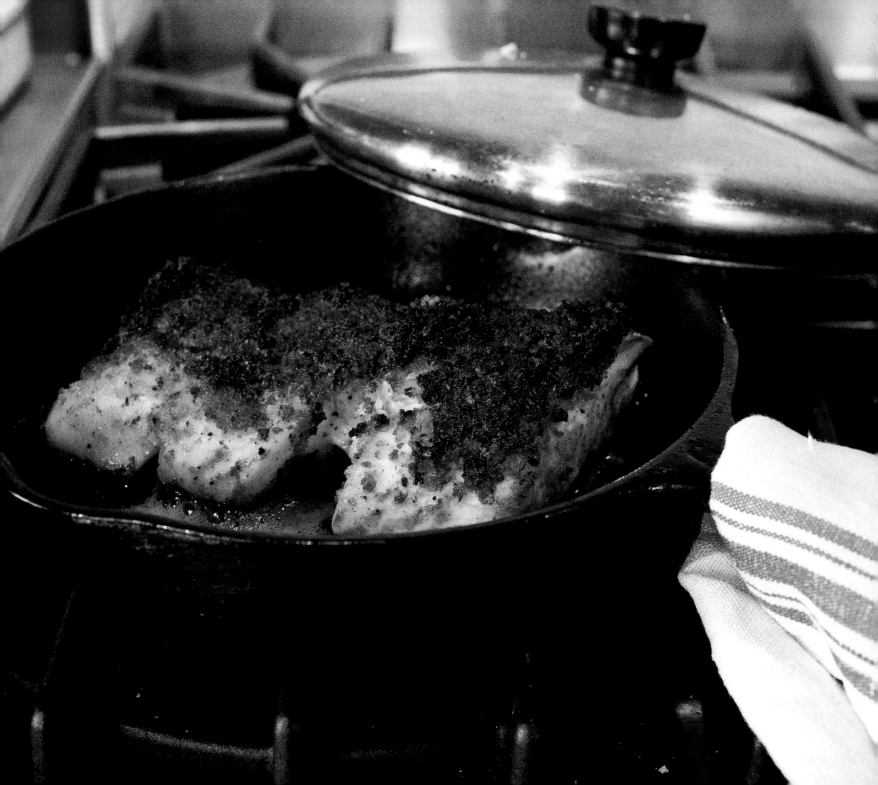

Pan-Seared Bass

Bass is delicious cooked on the grill, using the same recipe we've shown for bluefish. This is the way we prefer it.

What you need:
Striped bass fillets, skin on
Dab of butter
Sea salt

Slice fillets into 3- to 4-inch pieces and place them skin side down in a cast-iron pan.

Pour marinade over the fillets and place in the refrigerator for an hour. (See fish marinade, page 45.)

Preheat your broiler. On the stove top, cook the bass fillets at high heat for approximately 4 minutes, depending on the thickness (2-inch fillets = 4 minutes).

Cover the pan for the last 2 minutes of cooking. Remove the pan cover on the fish and generously spoon breadcrumbs (recipe at right) on top of each fillet. Add a dab of butter and a pinch of sea salt to each.

Place the pan under the broiler and cook 4–5 minutes. Keep a careful eye on this so that the breadcrumbs blacken, but not too much.

When serving, slip your spatula between the skin and the meat of the fish, leaving the skin in the pan.

We like to serve this with a fresh green salad with tomatoes and wild rice.

BREADCRUMBS

Breadcrumbs can be prepared a day or two before and kept in the refrigerator. I like to use ciabatta or a French baguette, and I make 2–3 cups at a time and freeze whatever I don't use immediately.

What you need:
Bread
2 tablespoons sweet butter
2 tablespoons olive oil
Mixed seasonings to taste (parsley, chives, basil, cayenne
 pepper, black pepper)
Sea salt

Cut the crust off the bread and break the soft bread into little pieces in a bowl.

Melt the butter and olive oil and pour over the crumbs, mixing until saturated. Sprinkle a pinch of seasonings and sea salt over the mixture and toss.

Place mixture on a cookie sheet and roast in a 325-degree oven until the breadcrumbs are golden brown. I usually check after 10 minutes, toss the crumbs, and then cook another 10 minutes.

Remove from oven. Once they are cooled I sometimes break up the crumbs into a smaller size.

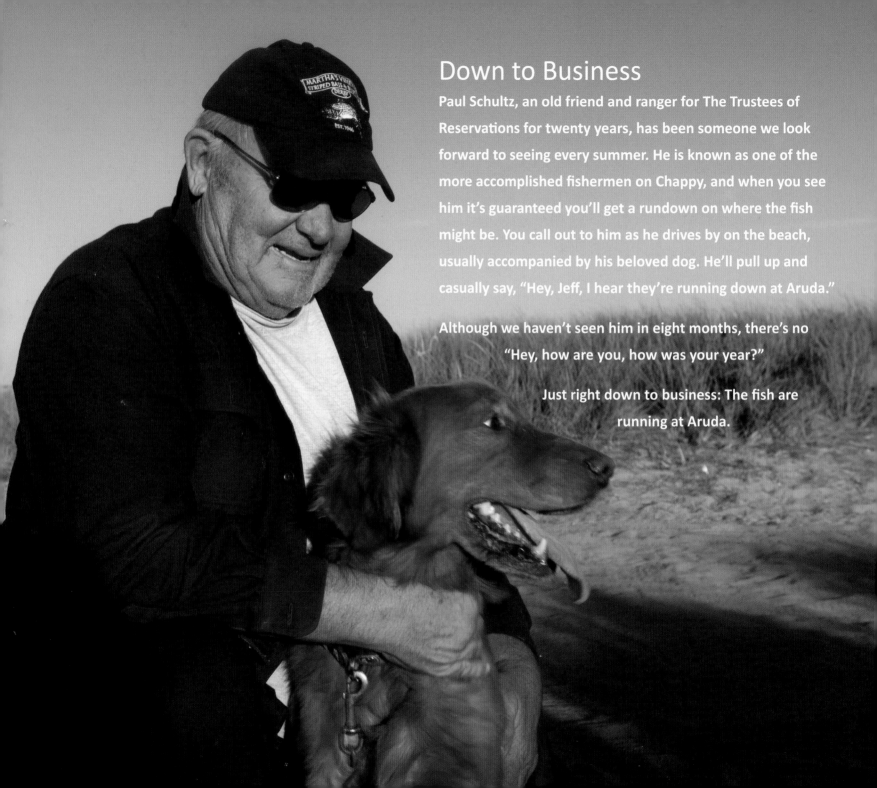

Down to Business

Paul Schultz, an old friend and ranger for The Trustees of Reservations for twenty years, has been someone we look forward to seeing every summer. He is known as one of the more accomplished fishermen on Chappy, and when you see him it's guaranteed you'll get a rundown on where the fish might be. You call out to him as he drives by on the beach, usually accompanied by his beloved dog. He'll pull up and casually say, "Hey, Jeff, I hear they're running down at Aruda."

Although we haven't seen him in eight months, there's no "Hey, how are you, how was your year?"

Just right down to business: The fish are running at Aruda.

Tomato and Basil

We love this as a side dish with the different fishes. We like to marinate it for an hour so that the flavors deepen. If you prefer it warm, it's also good cooked in a saucepan for a brief amount of time just before you're about to serve it.

What you need:
5 or 6 fresh tomatoes
Handful of chopped basil
1 clove garlic, pressed
2 tablespoons virgin olive oil
Pinch of sea salt

Quarter tomatoes on a board that will hold the juice. Push out most of the seeds with your thumb and discard.

Dice the tomato and place in a mixing bowl. Add basil and garlic into the mixture.

Pour olive oil over the mixture and toss lightly. Add sea salt to taste.

Set aside for an hour.

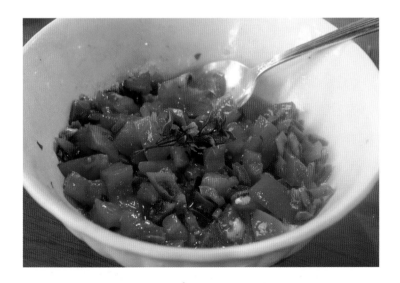

Fishing off the Boat

There's an adrenalin rush that comes with taking the boat out into the wild. There's a feeling of vulnerability, an exposure to the elements, the power of the sea and its currents, its vastness and its beauty, combined with the excitement of the catch. One of the great experiences a fisherman can have on a boat is being right in the middle of the action, the fish coming out of the water in pursuit of the lure, and using a small rod with light tackle so you can feel every movement.

There are certain spots you come to know where the fish will be, depending on the time of year. Jeff refers to one favorite spot as "The Market" because it's a sure bet that he'll be able to bring home dinner.

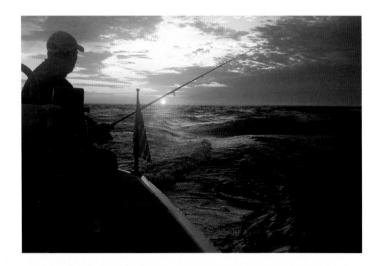

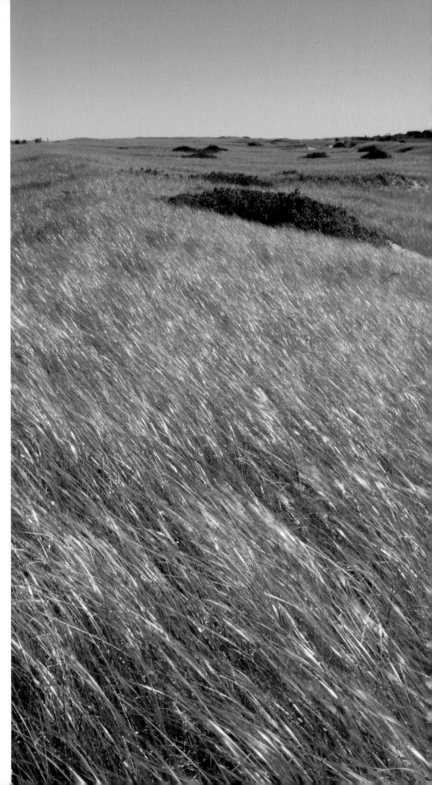

I enter the mounds of brown and green brush and bramble. From a distance they look like no more than the humped backs of buffalo moving through the windblown sea grasses.

—B.W.

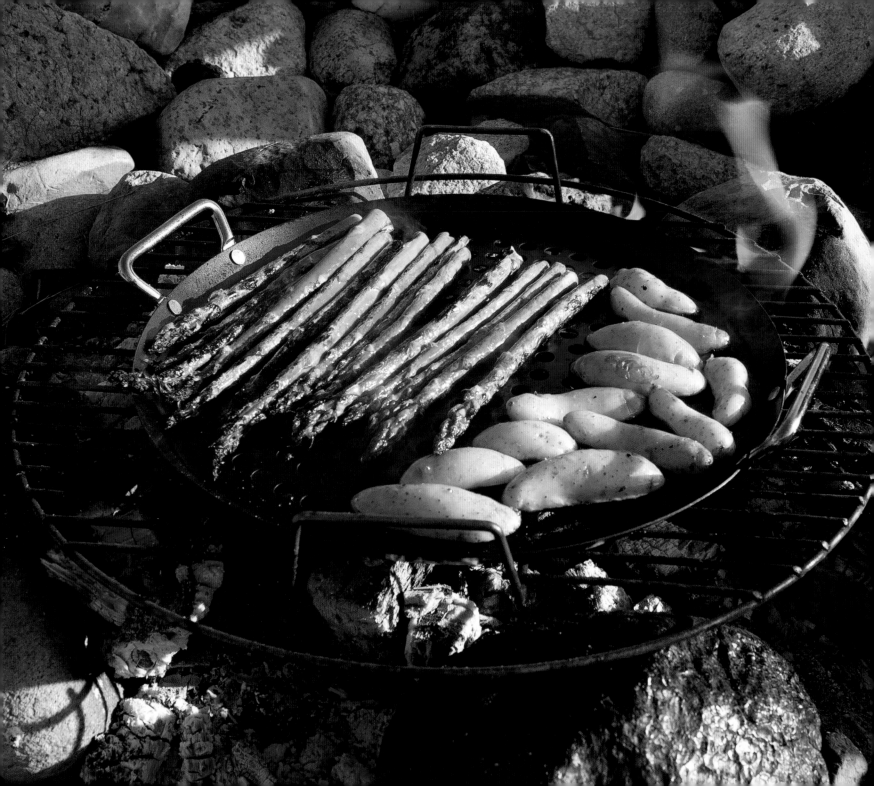

Fire-Pit Veggies

The fire pit is a gathering place before and after dinner. Before dinner we cook clams and oysters on the grill for appeti[...] *enjoy the sunset. After dinner we end up toasting some marshmallows followed by coffee or a nightcap under the stars.*

Just as with the fish we cook, the vegetables we choose for dinner each night are fresh each day, either picked from our garden or from one of the local farms.

What you need:
Fresh vegetables, such as peppers, zucchini, onions, asparagus, and fingerling potatoes
Olive oil
Sea salt to taste

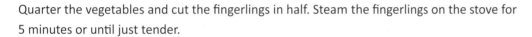

Quarter the vegetables and cut the fingerlings in half. Steam the fingerlings on the stove for 5 minutes or until just tender.

Place all vegetables and potatoes in a bowl and coat them lightly with olive oil. Sprinkle some sea salt and toss.

Place everything on a grill pan. We place the pan right on the grill and then cook them 4 or 5 minutes a side, depending on how hot your fire is. Use a metal spatula to flip the veggies.

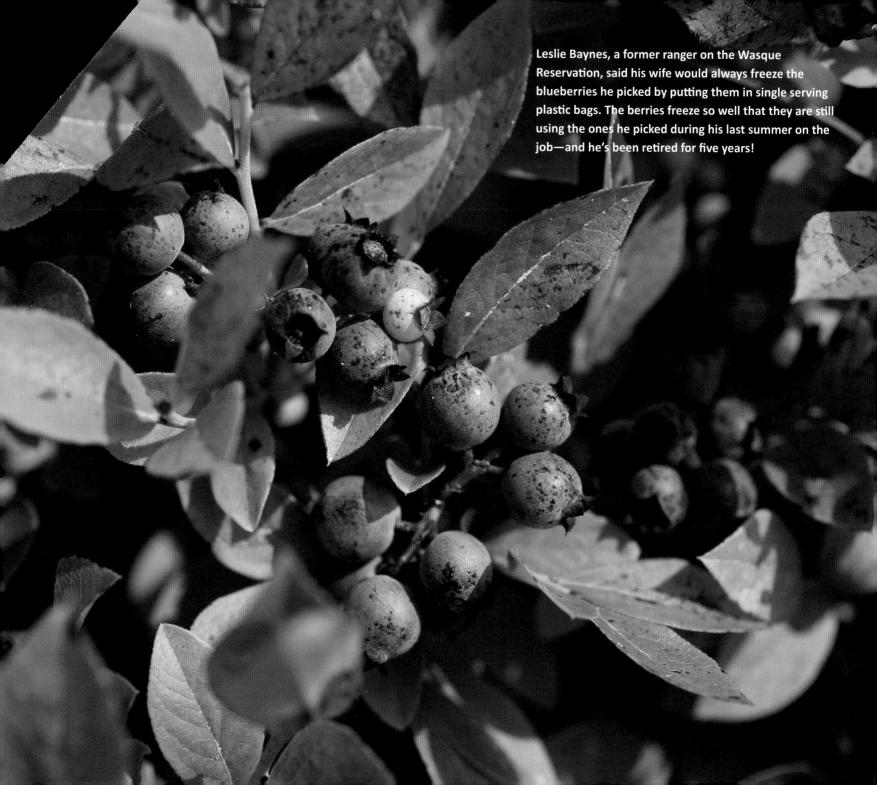

Leslie Baynes, a former ranger on the Wasque Reservation, said his wife would always freeze the blueberries he picked by putting them in single serving plastic bags. The berries freeze so well that they are still using the ones he picked during his last summer on the job—and he's been retired for five years!

(Ode to) Wild Blueberries

Wild blueberries are among the greatest of pleasures of this island. They grow naturally in abundance on the wide-open Wasque Plains, an area we like to call the Serengeti. Wasque is an old Indian name meaning the ending, and it's the very southeastern point on the island. While you won't see wild animals other than a few deer, you do feel like you're at the end of the world.

This great expanse is part of the one thousand acres and miles and miles of beach preserved by The Trustees of Reservations, a private, nonprofit organization established in Massachusetts for the purpose of acquiring and maintaining beautiful properties for the public's enjoyment.

Thanks to some generous island residents who donated the land years ago to The Trustees it will never be built on and it will remain free to enjoy forever. Henry Beetle Hough, the legendary editor of the *Vineyard Gazette* as well as a dedicated conservationist, said of land preservation, "Does anyone ask what it is good for? It does not have to be good for something. It is good."

The Wasque Plains are indeed good. The wild blueberries flourish under these ideal conditions of glacial soil, salty air, and warm breezes. Packs of seagulls hover over sections of open plains and give away the secret that the berries are

ripe and ready. We arm ourselves with buckets and bowls and then scatter in different directions, trudging through the low bushes and the scrub pines looking for the best spot. "I hit the jackpot!" is heard time and again.

When the buckets are full—sometimes even some pockets and occasionally the inside of a hat—we head home with the riches, daydreaming of what's ahead . . . blueberry pancakes, warm blueberry bread, and probably a blueberry pie.

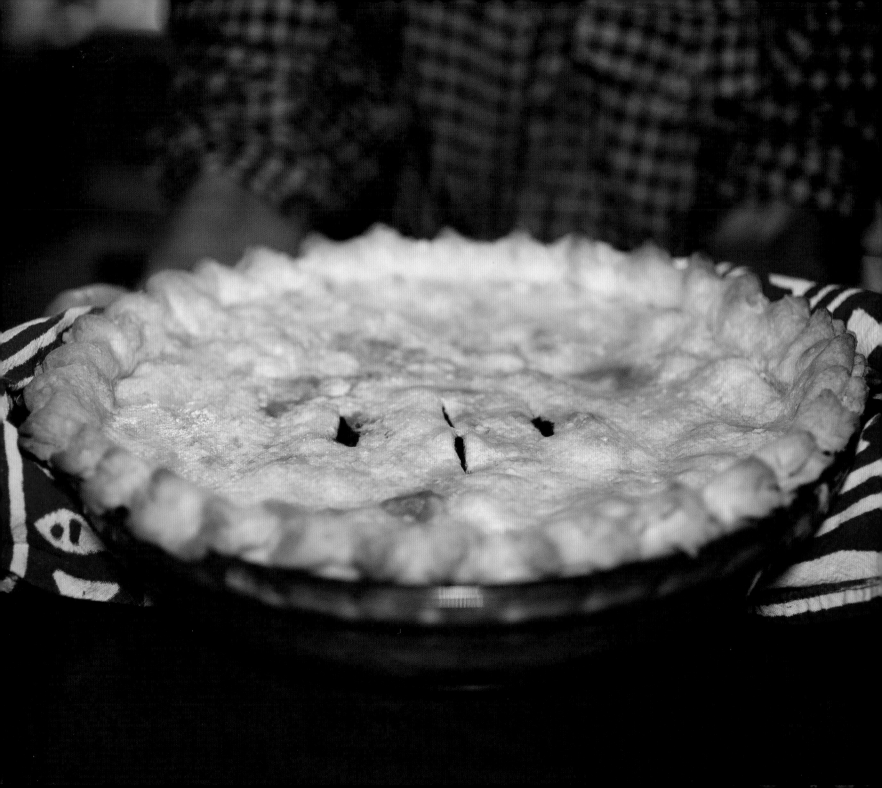

Wasque Wild Blueberry Pie

What you need:

3–4 cups wild blueberries

2 cups flour, plus a little more for filling

¼ to ½ cup sugar

¾ cup Crisco

2 tablespoons good-quality butter,
 plus more for interior of pie

1 teaspoon sea salt

5–6 tablespoons ice water

½ lemon

Waxed paper

Filling

Put blueberries in a large bowl and use just enough flour to coat them. Add sugar and pinch of sea salt. Toss gently and let sit.

Crust

Mix flour, Crisco, butter, and sea salt with a pastry blender until the mixture has pea-sized lumps.

Add ice water a few tablespoons at a time. (I use a three-pronged kitchen fork to mix in the water until it feels like it's just moist enough to form into a ball.)

Divide the ball into two balls and flatten them into 1-inch-thick discs. Wrap each in wax paper and refrigerate for an hour or so.

Roll out the dough on a floured board, creating both top and bottom of the pie. Place bottom layer in pie plate.

Add blueberry mixture and squeeze ½ lemon over the berries. Add a few dollops of butter on top of the berries.

Position the top layer of dough and pinch the edges to seal the top and bottom doughs. Pat milk or cream on the top. Add a sprinkling of sugar.

Bake for 10 minutes at 425 degrees, then 30 minutes at 375 degrees.

Let cool for 10–15 minutes before you slice so that the filling gels a little.

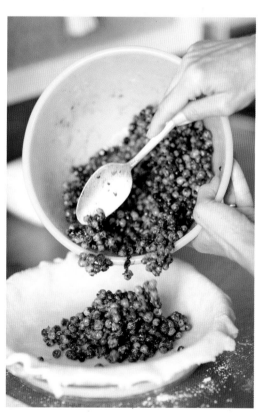

Blueberry Pancakes

What's better than a stack of hot blueberry pancakes with maple syrup and butter melting over the sides?

What you need:

1½ cups flour

1 teaspoon sea salt

2 tablespoons sugar

1¾ teaspoons baking powder

2 egg yolks

3 egg whites

3 tablespoons melted sweet butter

1 cup whole milk

1 teaspoon vanilla

Butter for the grill

Combine all dry ingredients in a large bowl.

In a second bowl, whisk together yolks, butter, milk, and vanilla. Stir into dry ingredients until combined.

Beat egg whites until stiff in a third bowl. Fold the whites into the mixture.

Melt a small amount of butter on your griddle pan and let the pan heat up. Pour large spoonfuls of the batter on the pan. Cook 2 or 3 minutes.

When bubbles start to appear, sprinkle a handful of blueberries on the cakes and cook another minute. Flip and cook for another minute or two, depending on the size of the cake.

"My room seems a ship's cabin and at night when I wake up and hear the wind shrieking, I almost fancy there is too much sail on the house, and I had better go on the roof and rig in the chimney."

—Herman Melville

Thunderstorms out on the bluff where our cottage is give us an appreciation of what it must be like out on the open ocean in a boat during a storm. The lightning illuminates the room, the thunder makes the cottage tremble, the rain pounds on the roof. Unlike the vulnerability of a boat, we feel secure in this aerodynamically designed structure, a true fishing camp. We stoke the wood-burning stove, turn out the lights, snuggle under a layer of blankets, and watch the storm's performance out of the bedroom windows.

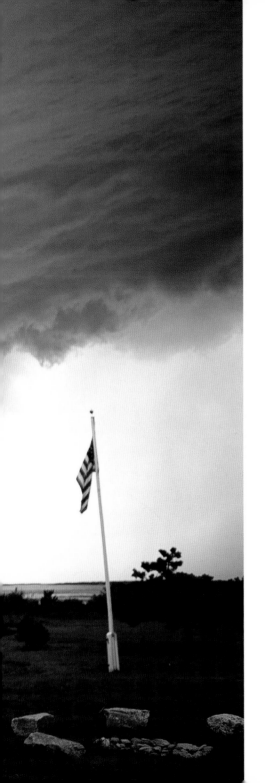

Weathering

There is a romance in withstanding the elements. Perhaps a primal satisfaction in weathering that which wears you down. Maybe it is the Yankee influence that runs through Chappy, but those of us who live here do seem to take particular pride in gains wrought through this weathering challenge.

Pies taste better when the berries are hand-picked through mosquitoes and poison ivy. Bluefish, plated by hands callused by the catch, are that much tastier. And we cherish our clothing here that has been through the battles. The wool sweater, a hole in the armpit and hardened by salt, is favored over the cashmere number that hangs neatly next to it. The oil-stained waders are as much a trophy as they are a necessity—displayed where one can enjoy.

Chappy allows us every opportunity to challenge our patience and resilience. And we avail ourselves often, because the rewards are great.

—B.W.

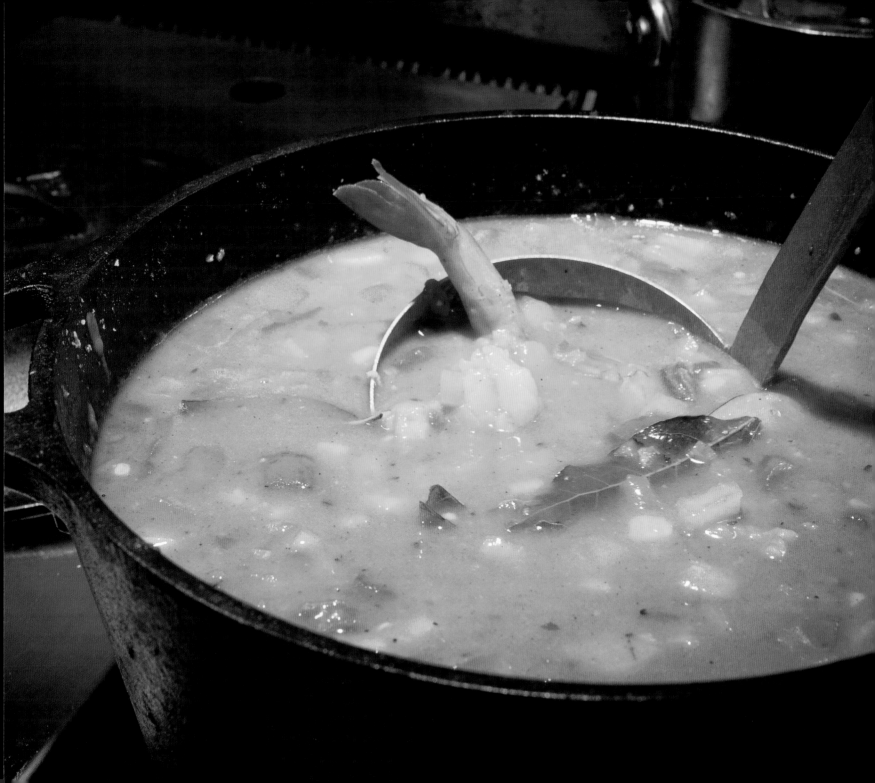

Victoria's Chappaquiddick Gumbo

"How's your mamma? How's her roux?" is what they say in Louisiana where our daughter-in-law was raised. The roux is the essential ingredient in a good gumbo. With a good roux as the base, you'll be pleased with the taste and texture of your gumbo. Victoria learned this recipe from her Grandma Rosie. She usually makes this with chicken, but we adapted it to call for fresh bass and bluefish.

What you need:

2 packages of Andouille sausage, 14- or 16-ounce sizes

3 sweet onions, chopped

3 bell peppers, chopped

5–6 stalks celery, chopped

3 bay leaves

2 teaspoons sea salt

½ teaspoon ground pepper

½ teaspoon cayenne pepper

Pinch of thyme and oregano

½ cup vegetable oil

1 cup flour

6–7 cups fish stock (see page 113)

4 cups chunks fresh striper

1 cup bluefish chunks

Dozen shrimp

Tabasco sauce

Brown rice, cooked according to package

Slice and brown the sausage in a deep cast-iron pan in 1 teaspoon of vegetable oil. Drain sausage on a paper towel.

Combine bay leaves, sea salt, ground pepper, cayenne pepper, thyme, and oregano in a bowl and set aside.

To make the roux, use the leftover oil from the sausage, add ¾ cup vegetable oil, and heat on high until smoking hot.

Carefully stir in 1 cup flour gradually, about ⅓ cup at a time, stirring or whisking constantly.

Stir flour mixture constantly on medium-high heat 15–20 minutes, until it reaches a rich brown color.

Turn heat to medium, and add half of the chopped vegetables to the roux. Stir until they are well mixed.

Add the remaining vegetables and cook a few minutes more. Stir in the seasoning mix and remove from heat.

Heat fish stock in a double boiler. Bring to a boil.

Place roux back on medium heat, and gradually pour boiling broth over the roux while stirring constantly.

Add the chunks of fish, the shrimp, the sautéed sausage, and a few shakes of Tabasco (depending on how hot you like the taste).

Boil gumbo for 10–15 minutes, then turn the heat down and cook for an hour at medium heat, stirring occasionally and skimming oil from the top.

Meanwhile, cook brown rice. Serve gumbo over rice.

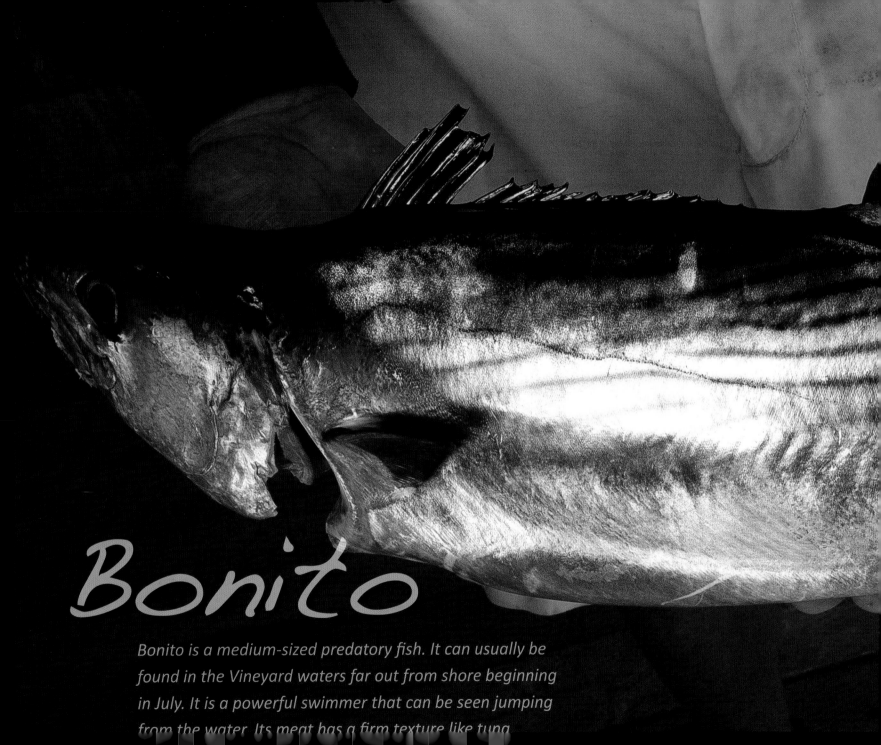

Bonito

Bonito is a medium-sized predatory fish. It can usually be
found in the Vineyard waters far out from shore beginning
in July. It is a powerful swimmer that can be seen jumping
from the water. Its meat has a firm texture like tuna.

While bluefish may be the most underrated fish, Bonito attract the most attention. Bonito rarely hit before mid-July, but when they do, the talk of the catch sweeps the island: "Did you hear a bonito was caught out at the Hooter?"

If you've witnessed a bonito coming directly out of the water, it's understandable why it draws attention. They have a magnificent silver, greenish, purplish coat of armor that dulls within minutes of being caught. When you catch one you feel that you've been privy to a rare and beautiful sight.

The bonito is also a great sporting fish. It's a terrific challenge to bring one in because of the way it rapidly darts and zigzags, pulling your line for great distances.

Its cousin, the false albacore, shows up in droves at the end of August. It can be an even better fight for the fisherman and is considered by some to be even more beautiful. But as its name implies, it's an impostor. Unlike the delicious bonito, it's inedible.

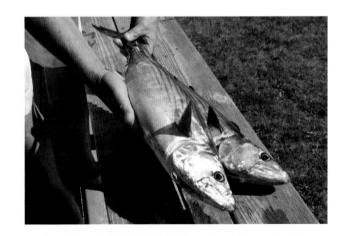

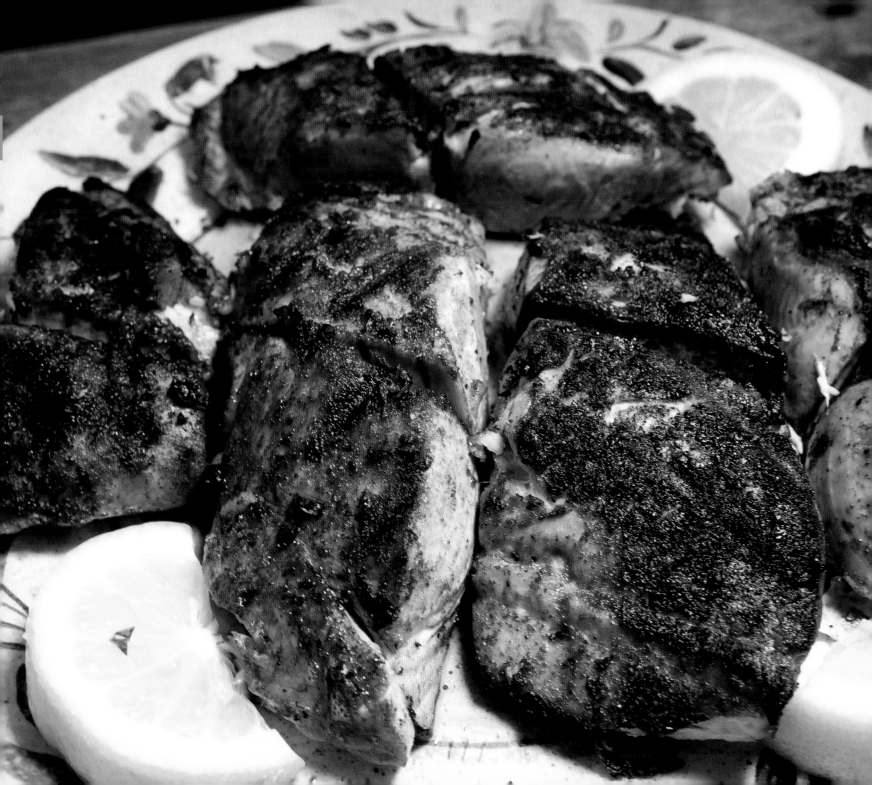

Chipolte Bonito

This spicy rub gave the fish a real kick, bringing out a rich flavor.

What you need:
Fillets of bonito
Chipolte spice (available in most grocery stores)
Few tablespoons butter
Lemon
Sea salt to taste

Fillet your bonito and place them skin side down in a baking pan.

Rub a generous amount of chipotle spice onto the fish fillets, then place in the refrigerator for an hour.

Melt a few tablespoons of butter and the juice of a lemon and gently pour over the fillets, trying not to let the chipotle spice run off. Let this marinate for another hour.

Shake some sea salt over the fish.

Grill at a hot temperature (500–600 degrees) for 5 minutes.

Slip your spatula between the skin and the fish, and gently flip the fish off its skin, and grill for another 5 minutes.

Growing Up on Chappy

Summer on Chappy always felt like a sleepaway camp. We'd bike for blueberries and grape leaves, sit around campfires, and spend our days on the water just a short walk down the dirt road. We'd make up countless games on

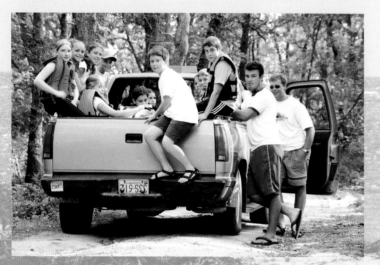

the beach in the day and watch the sun go down with s'mores and a warm blanket at night.

I used to love my day camp at the Chappy Community Center. After a school year filled with scheduling, working, and studying, nothing felt better than spending time on the water with my best buds. When we piled into the overstuffed pickup truck every Monday and Wednesday, there were no expectations, and certainly no pressures. It was a blast!

Sailing, racing, swimming, and even capsizing in our boats each week left a lasting impression on us. The lessons we learned about the art of sailing, and the friendships we made on the water, still linger with us today.

With the passing of time (much like the Chappy beaches), we are all aged and altered. But when we return each summer, no time is lost. We make room for new traditions and hold tight to the memories that made this little island a home.

—Charlotte Fager

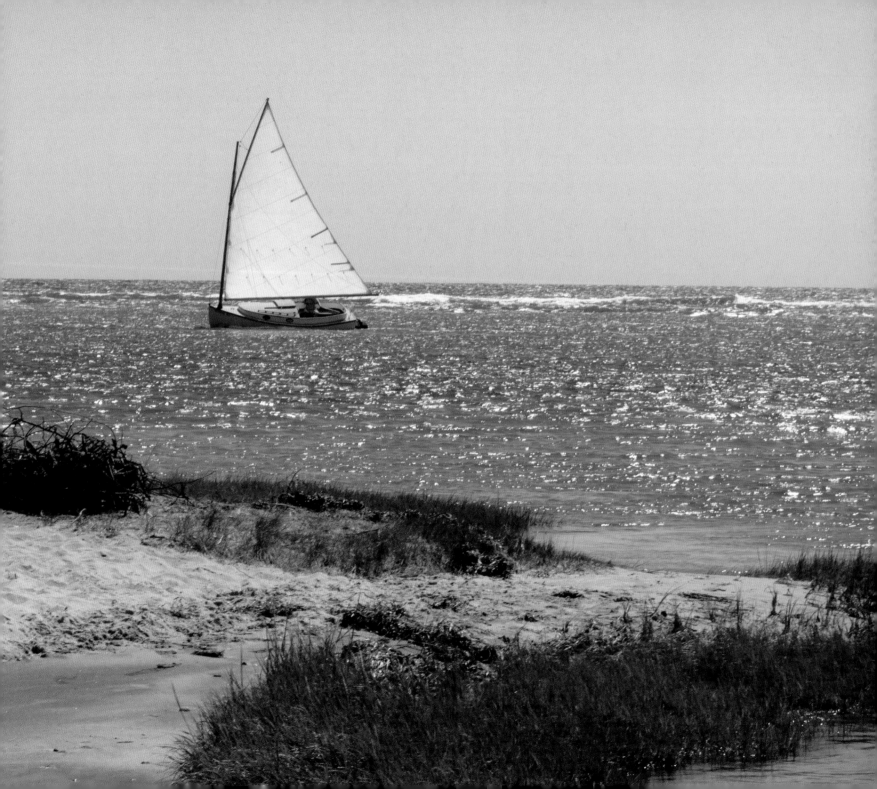

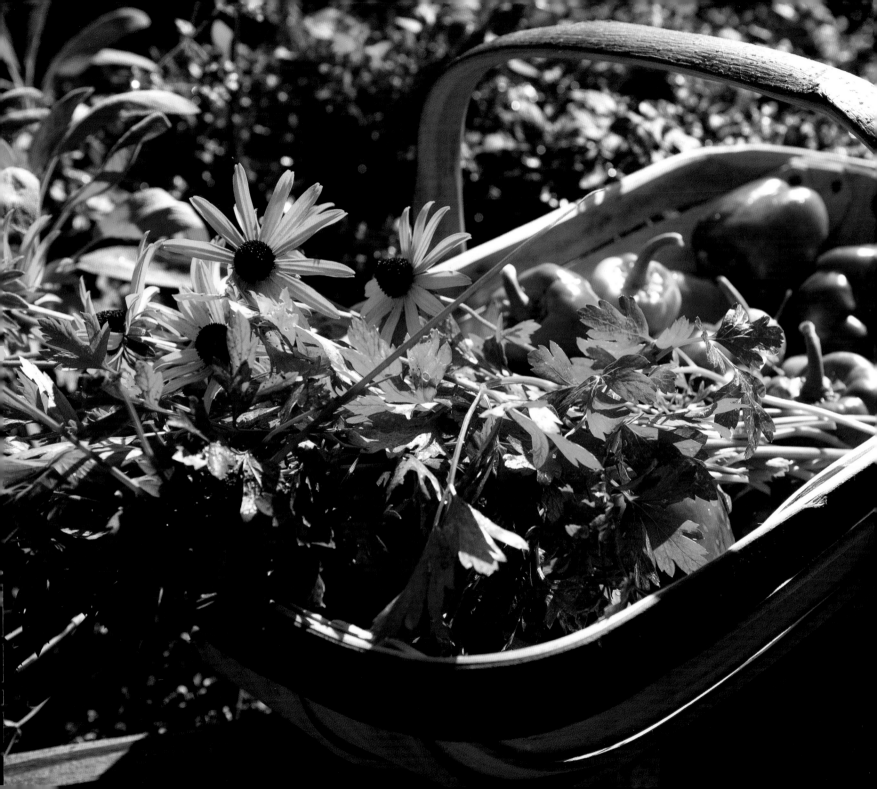

Tomato, Radish, and Cucumber Salad

This is a particularly good and simple side dish for the bonito. New spring radishes make the difference. They're crisp and spicy.

What you need:
5–6 fresh tomatoes
Handful of mint and fresh chives
6 radishes
2 cucumbers
Sea salt
Good-quality olive oil

Quarter the tomatoes on a board that will hold the juice. Push out most of the seeds with your thumb and discard.

Dice the tomato. Pour juices and diced tomato into a mixing bowl.

Chop mint and fresh chives and add to the tomatoes.

Dice radishes and cucumbers and add to the mix.

Sprinkle on sea salt to taste and drizzle lightly with olive oil. Toss gently.

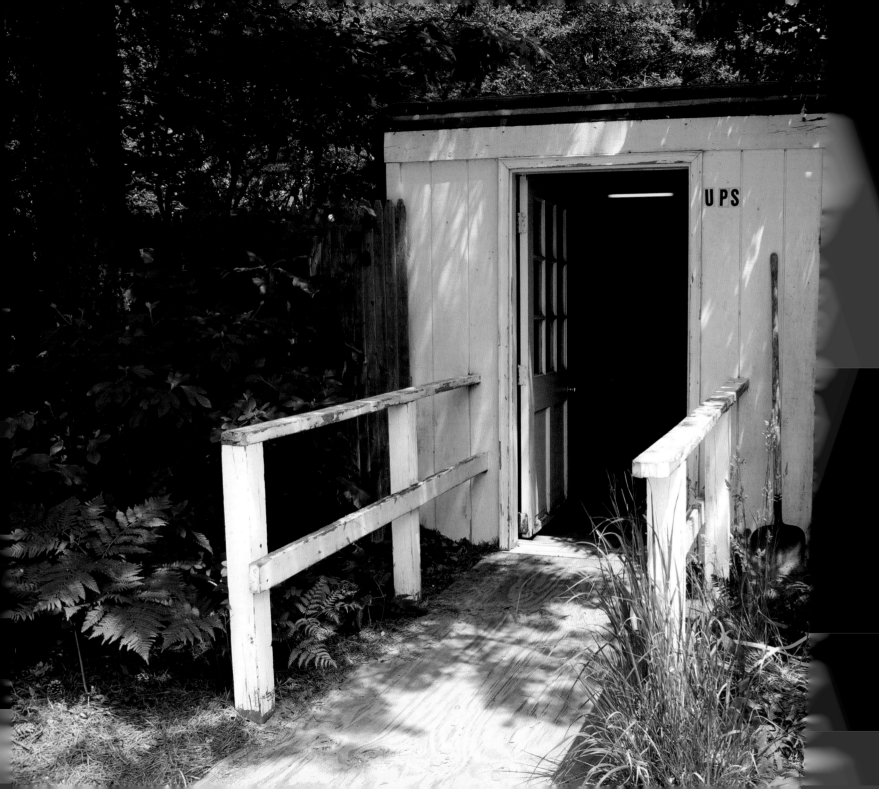

UPS Store

I imagine there aren't many places left where you pick up your packages as we do here on the island. Gerry Jeffers mans the tiny UPS shed where you walk in and exchange the usual greetings: "How's it going?" "Can't complain." Then you cross your name off the list on the clipboard and grab your marked package. Doesn't get much simpler than that.

Gerry also runs the Chappy Store, which is surrounded by a collection of abandoned cars and trucks. Many families have left a beloved but dearly departed vehicle at Gerry's, and many more have had bits and pieces of those same vehicles help to resuscitate their running ones.

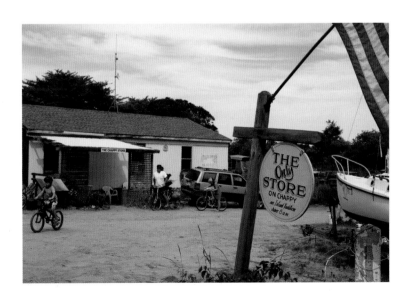

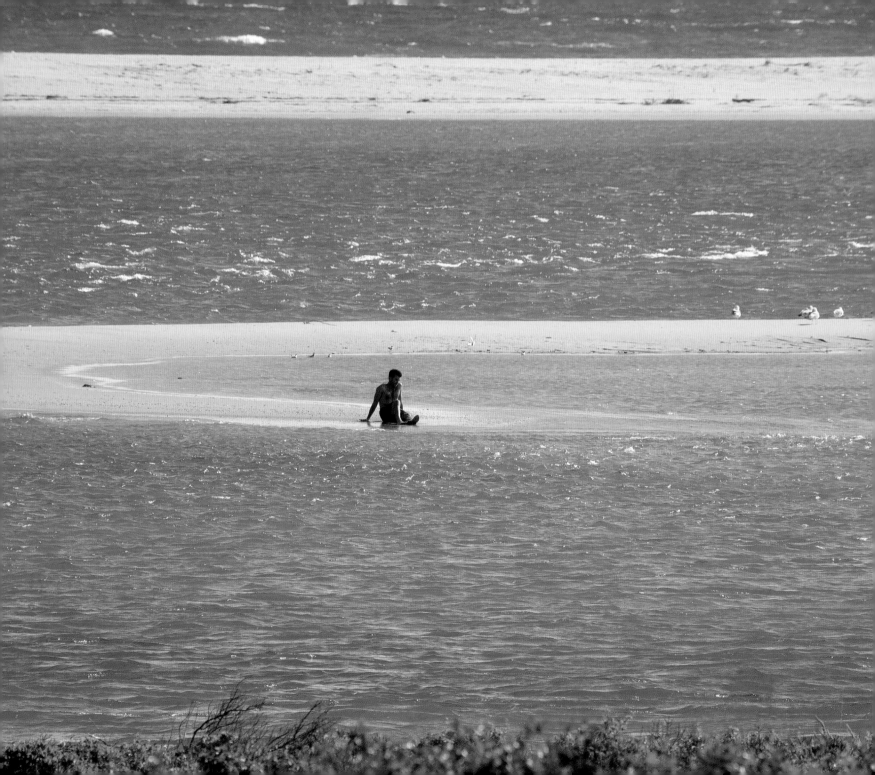

Blueberry Vodka Tonic

Blueberry puree added to a beverage makes for a beautiful summer drink. If there is any left over, I freeze the remainder in ice cube trays for use later individually or as little popsicles.

What you need:
Vodka
Tonic water
Mint
Blueberry puree (recipe at right)

In an old-fashioned glass filled with ice, add:
1 shot vodka
Tonic water
A few tablespoons of blueberry puree
Top with a sprig of fresh mint.

What you need:
1 cup blueberries
¼ cup simple sugar syrup
juice from 1 lemon

In a blender, combine all ingredients.

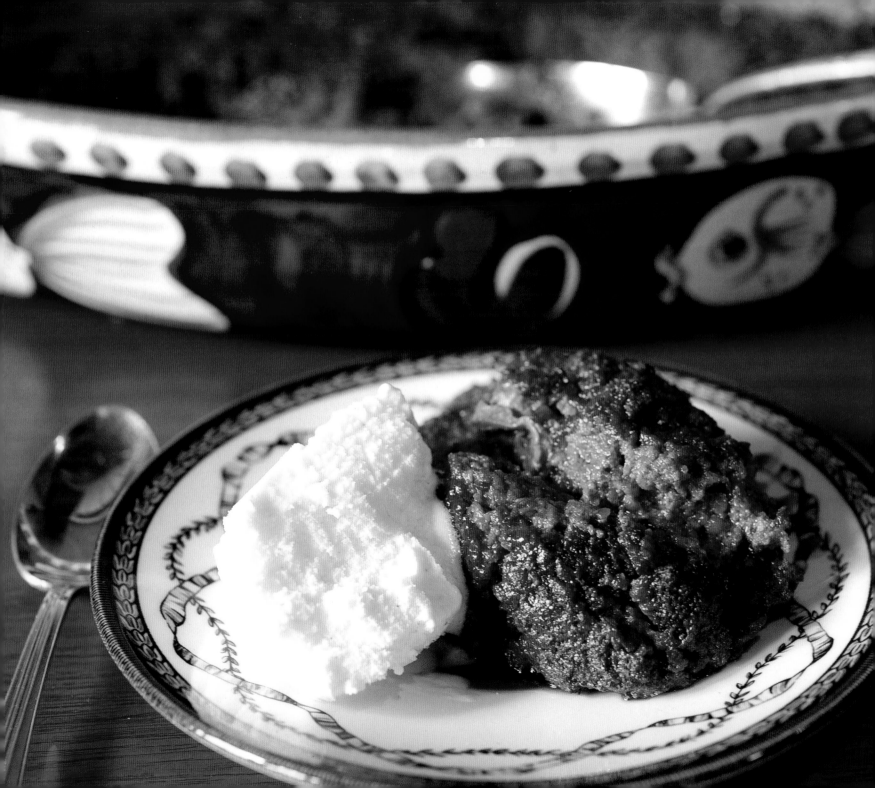

Indian Pudding: *A variation on Sally Jeffers's Spoon Pudding*

There's only been one restaurant on this island in its history, and it was called the Chappaquiddick Outlook. Sally Jeffers started it in 1922 or 1923 and ran it with her relatives for about thirty years. It was located on Cape Pogue, where she had a barn with cows, chickens, and guinea hens and a garden for her fresh vegetables. She'd serve up formal meals for up to sixty people all summer, and sometimes she'd have big clambakes on the beach. Diners would sometimes row over from their yachts moored in the Edgartown harbor. As the story goes, no matter where you dined—at either the restaurant or on the beach—you had to wear your Sunday best. That's the way Sally wanted it.

Sally Jeffers never wrote down her recipes, and I haven't been able to find anyone who copied them down. She was the kind of cook who used a little of this, and a little of that, and as legend has it, it came out right every time.

This spoon pudding recipe is one my mother used to make, and it seemed fitting since the Jeffers family are descendants of the Wampanoag Indians, who still have a tribal reservation on Martha's Vineyard.

What you need:

4 cups milk	2 fresh eggs, separated
3 tablespoons yellow corn meal	½ teaspoon salt
2 tablespoons butter	¾ teaspoon cinnamon
1 cup molasses	½ teaspoon ginger

In a double boiler scald 4 cups milk. When it's hot, but not boiling, whisk in the corn meal.

Cook this mixture for 15 minutes, stirring often.

Add butter and molasses and stir until butter is melted and blended.

Add egg yolks, salt, cinnamon, and ginger to corn meal mixture.

Beat egg whites until firm but not dry, and fold them into the batter.

Pour into a greased 8-inch baking dish.

Bake at 350 degrees for 1½ hours.

Serve with ice cream.

Living Off the Sea

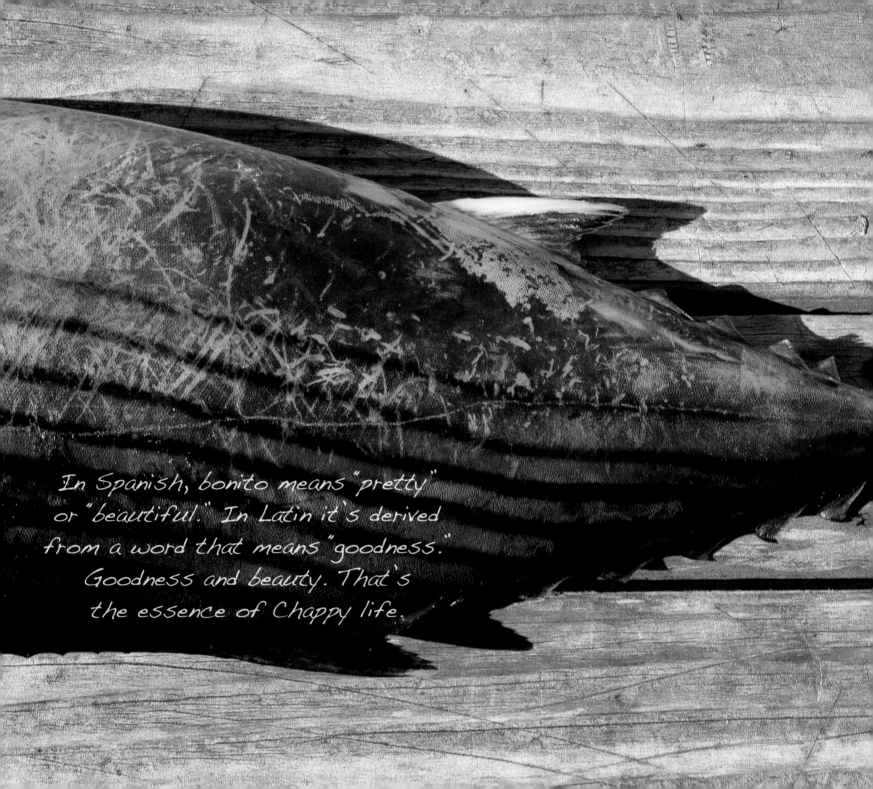

In Spanish, bonito means "pretty"
or "beautiful." In Latin it's derived
from a word that means "goodness."
Goodness and beauty. That's
the essence of Chappy life.

Bonito Steaks

What you need:
1½-inch-thick bonito steaks
Olive oil
Salt and pepper to taste
Melted butter
Juice from lemon

Rub both sides of steaks with olive oil and place on a hot grill (500–600 degrees). Cook for 2 minutes on each side.

Salt and pepper each steak, and pour melted butter and lemon juice on top when serving.

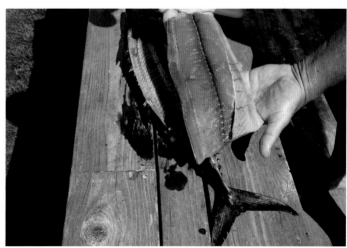

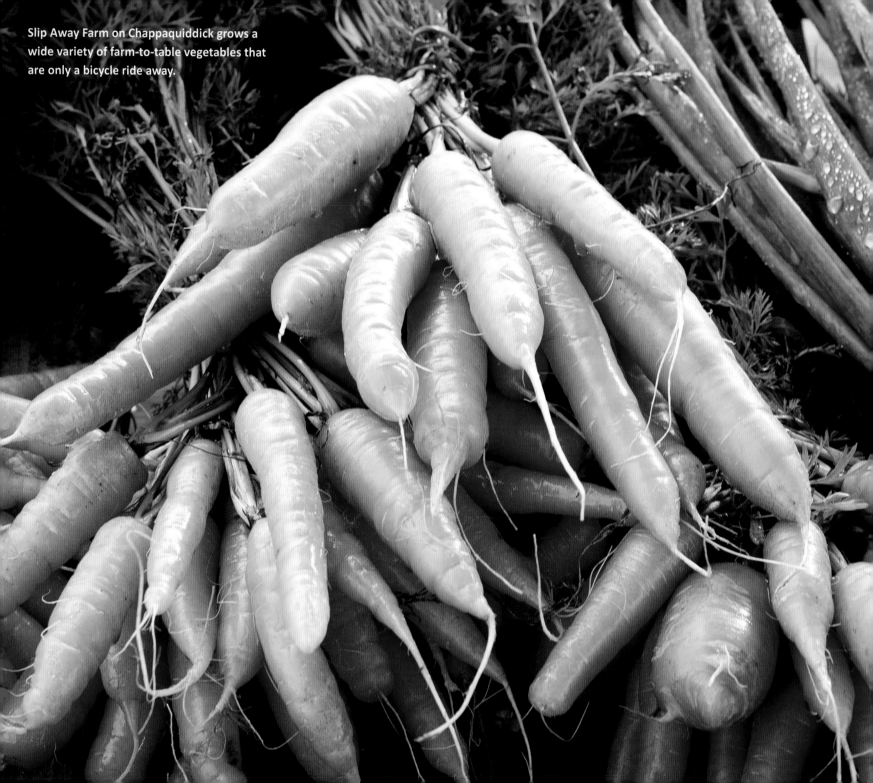

Slip Away Farm on Chappaquiddick grows a wide variety of farm-to-table vegetables that are only a bicycle ride away.

Skunked Pasta

When you're ready for a break from fish, or the fish aren't there to be caught, this is our go-to recipe.

What you need:

½ cup goat cheese

1 or 2 cloves garlic, minced

10 fresh basil leaves, chopped

1 tablespoon chopped chives

½ tablespoon chopped rosemary

1 tablespoon olive oil

5 cups chopped fresh tomatoes

1 package fettuccine pasta

Salt and pepper

In a bowl, mix the goat cheese, garlic and chopped herbs by hand. (Add only 1 tablespoon basil, reserving rest.)

Heat olive oil in a large sauté pan. Add tomatoes and rest of the basil and cook for 5 minutes. Salt and pepper to taste. While preparing this, cook pasta al dente.

Dish out pasta to each plate and spoon the tomato sauce on top.

Crumble 4 or 5 little balls of the goat cheese mixture on top.

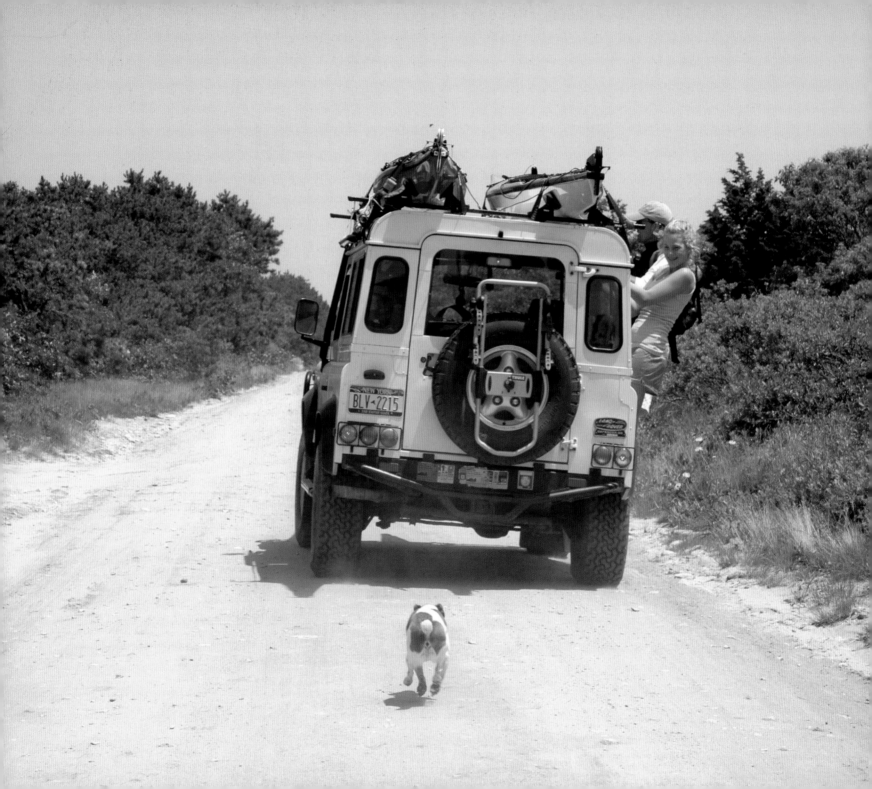

Tackle Box

I was told that if an experienced fisherman opened up Jeff's tackle box he could tell where he fished and what he was going for, just by looking at the lures.

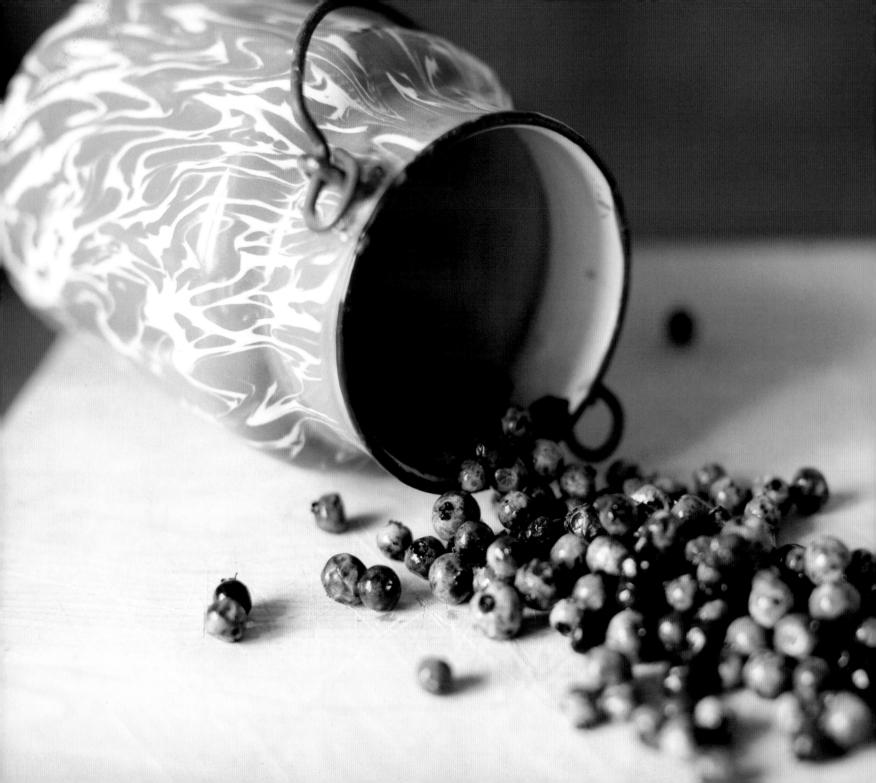

Hot Blueberry Sauce

Wild blueberries are sweeter than the cultured ones, so you won't need as much sugar in your recipes.

What you need:
2 cups wild blueberries
Water
¼ cup sugar
1 tablespoon lemon juice
1 teaspoon cornstarch

In a saucepan, heat the blueberries, sugar, and lemon juice. Add ¼ cup water. Boil for 2 minutes.

In a separate container, mix cornstarch in just enough hot water to dissolve it. Add to berries, and let boil another minute. If it's too thin, cook another few minutes.

Take off the stove and let it cool slightly.

Serve warm over ice cream.

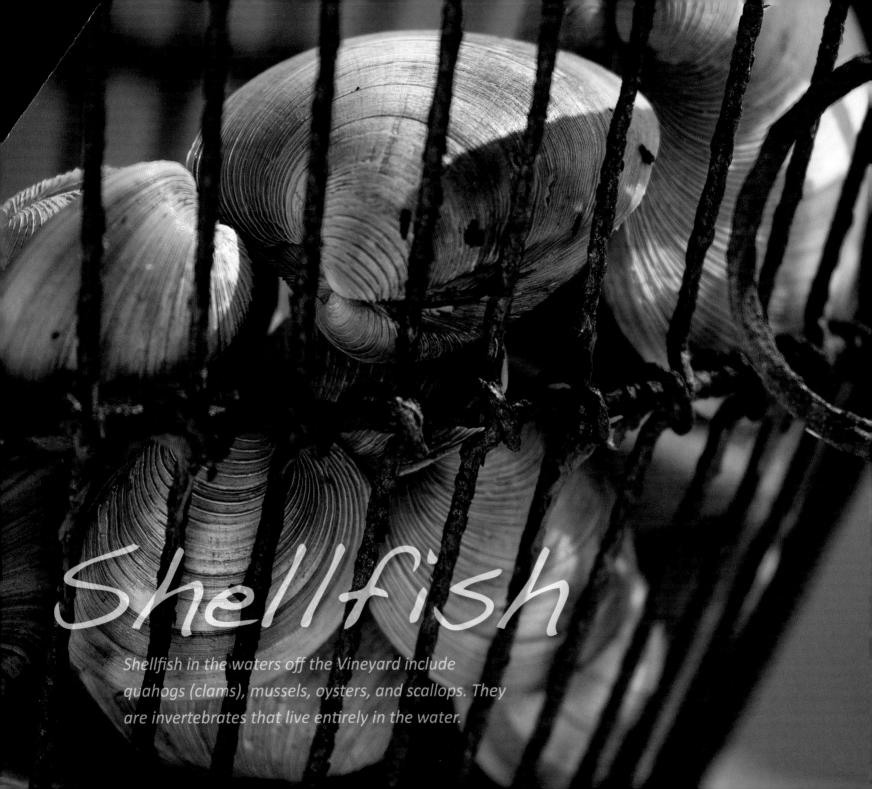

Shellfish

Shellfish in the waters off the Vineyard include
quahogs (clams), mussels, oysters, and scallops. They
are invertebrates that live entirely in the water.

The waters that surround us have always been known for being rich with shellfish. We've enjoyed watching a steady pilgrimage of people armed with wire baskets and rakes heading down to this southeast corner of the bay in search of quahog clams. There are also thousands of mussels hugging the underside of the sea grass that borders the bay. And some of the sweetest oysters we've tasted are now being farmed in the outer reaches of Edgartown Harbor.

Scallops are in abundance at many different locations around the Island. So many shellfish, so many possibilities for recipes. We cook them on their own, we mix them together, we use them to add to pasta dishes, or we just enjoy them raw in the half shell.

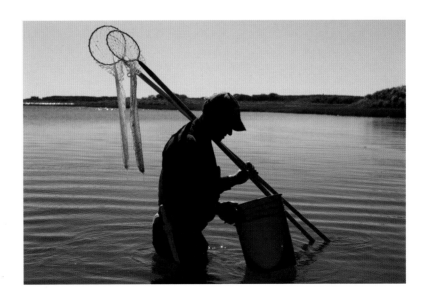

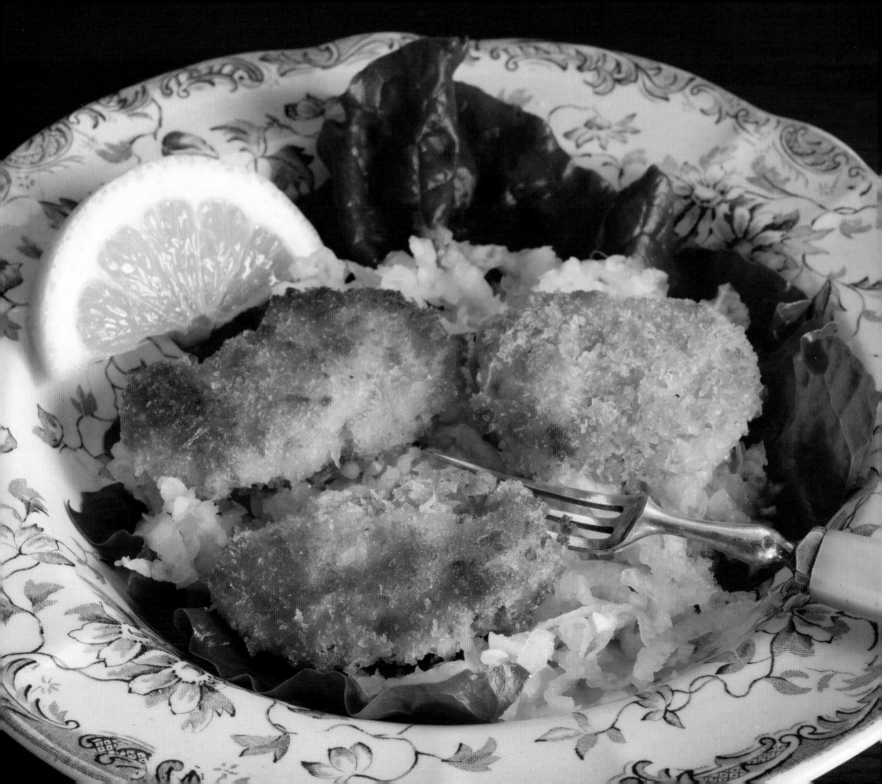

Katama Oysters over Fennel

I learned this recipe from our friend Rick Anderson. Rick is a Vineyarder who is as meticulous about his cooking as he is with his principal profession as a builder. He is constantly combing New England and Europe for ancient homes or barns that are being offered for sale or are in peril of being torn down. Once he acquires one he'll bring his crew in to disassemble the structure and number every plank, every terracotta tile, and every beam, to be reassembled here or around the New England area.

Every summer we look forward to his next innovative recipe. This one is a variation on one he learned from a friend who had been a chef at a local restaurant. It is, hands down, one of the best oyster appetizers ever. Always use the freshest local oysters. We use Edgartown Oysters, which are farmed right here in Katama Bay.

Rick likes to serve this with a homemade aioli sauce drizzled over the oysters.

What you need:
Shucked oysters. Allow 3–4 per person, and once shucked, allow them to sit in a bowl with their juices.
Flour
Sea salt and ground pepper
1–2 eggs, whisked with a touch of water

On your counter, prepare in different containers:

A plate with flour with a dash of sea salt and ground pepper

Eggs

A plate with a cup of Panko which has been rolled for finer texture (I put it in a plastic bag and use a rolling pin.)

Heat a grill pan and lightly oil it with canola oil.

Dunk each oyster in flour, then eggs, then Panko.

Drop oysters into hot pan and cook for 1 minute per side.

Serve oysters over grated fennel, and sprinkle with lemon juice and sea salt.

1 cup Panko (Japanese bread crumbs)
Canola oil for cooking
Grated fennel
Fresh lemon juice

AIOLI
What you need:
2 large egg yolks
¼ cup olive oil
2 tablespoons fresh lemon juice
1 clove garlic, minced

Whisk all ingredients until well mixed.

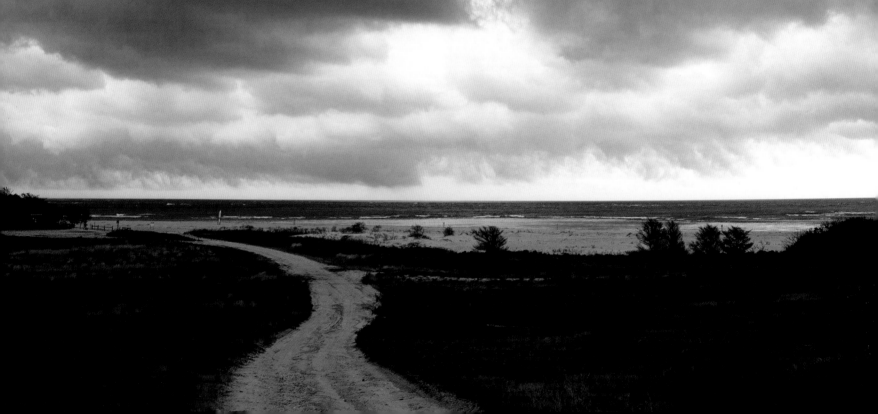

Seventeen Times

The day changed seventeen times.

Flannel shirt. T-shirt. No shirt. Flannel shirt again. And so
on. Another day may be different in its sameness. Uniformly
fallish. Breezy, crackling, clear.

We breathe it in, a wish perhaps fulfilled, while nature laughs
at our conceit that we have any say in matters of weather.

Like a feisty Cajun cook, Chappy serves us our fare, regardless
of our preference. And we are thankful.

—B.W.

Open Spaces

I've been stung by jellyfish. Bitten on my toes by crabs. Sliced by a razor clam. Frightened by a skate. Pooped on by a seagull. And not once have I seen "it" coming.

Each time, the insult to my being came upon me by the stealth that such open space provides. Vast are the sea and the sky above it. No amount of vigilance can cover every angle when there exist no angles, only infinite curves.

We often speak of being alone in these spaces, but we are never alone—only free of other people. Above the sea, Chappy envelops us in its own confluence of wind, sun, flora, fauna. Below the sea, we are in Chappy's womb—if only briefly. So there is a trust that we impart to Chappy that we don't always impart to our brethren.

Away from the crowds, we feel safe. We give in to Chappy—allow it to do with us what it will: Caress us. Rock us. Bite us. Poop on us. Chappy is also the rarest of friends, the one who treats us so well that we forget her transgressions.

It's all good, it's all forgiven.

—B.W.

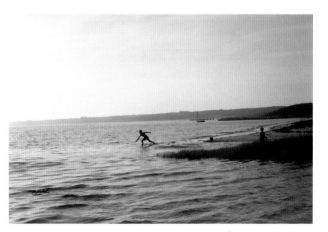

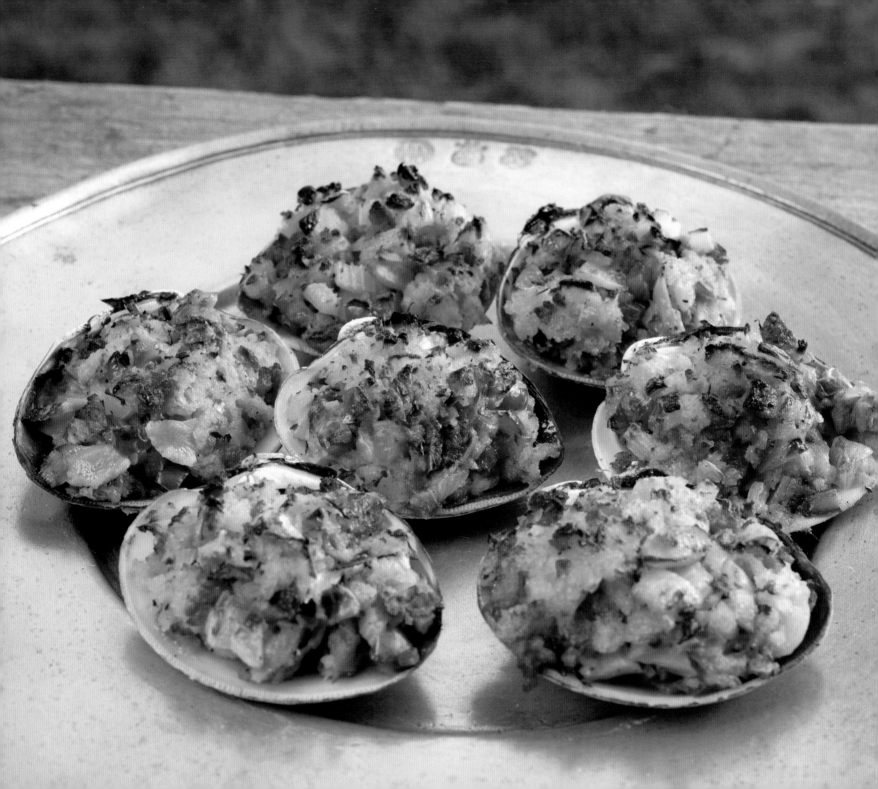

Stuffed Quahogs

When I need quahogs for a chowder or stuffers, or we just want to slurp some raw ones before dinner, I recruit the kids and we head down to the bay. Everyone has their own technique for digging: some on hands and knees, some feeling with toes, and others dragging the rakes. They all work, so that in no time we're back with a few dozen. I prefer to use the smaller clams for this recipe.

QUAHOGS ON THE GRILL

This is like the meat and potatoes of island life—a simple and basic traditional meal. It's one of our favorites at the end of the day just before dinner, with the sun setting, around the fire pit.

What you need:

A few dozen quahog clams

Throw them on a hot grill, wait for them to open, then dip them in some melted butter.

What you need:

12 medium-sized quahogs	Chopped parsley
2 or 3 links Andouille sausage	Melted butter
2 cups each of celery, onion, and	Lemon
fresh green peppers, chopped	Sea salt
Loaf ciabatta bread	Pepper

Steam the clams until they just begin to open. Pry open the shells over a bowl so that you save the clam juice, and save the shells.

Scoop out the clams, cut them up with a pair of kitchen scissors, and set aside.

Chop up the sausage and sauté lightly. Add the vegetables to the sausage and simmer until onions are translucent. Add clams to the pan.

Pull and shred pieces of bread from a ciabatta loaf, without the crust.

Add the bread to the bowl of clam juice and let it soak. "Knead" the bread until all the juice is absorbed.

Add the bread to the pan of sausage and vegetables, along with some chopped parsley, sea salt, and pepper. Mix all together.

Spoon mixture into empty shells and keep covered in the refrigerator until 10 minutes before you're ready to eat them.

Add a little melted butter to the top of each.

Place the shells on a cookie sheet and roast at 350 degrees for 5–10 minutes, depending on the size clam you've used.

Just before serving, turn the oven to broil, and brown the stuffed clams for 2–3 minutes.

Squeeze some lemon on each and serve.

Beach stickers on the trucks and
cars are like badges of honor.
They distinguish the most
seasoned fishermen and families.

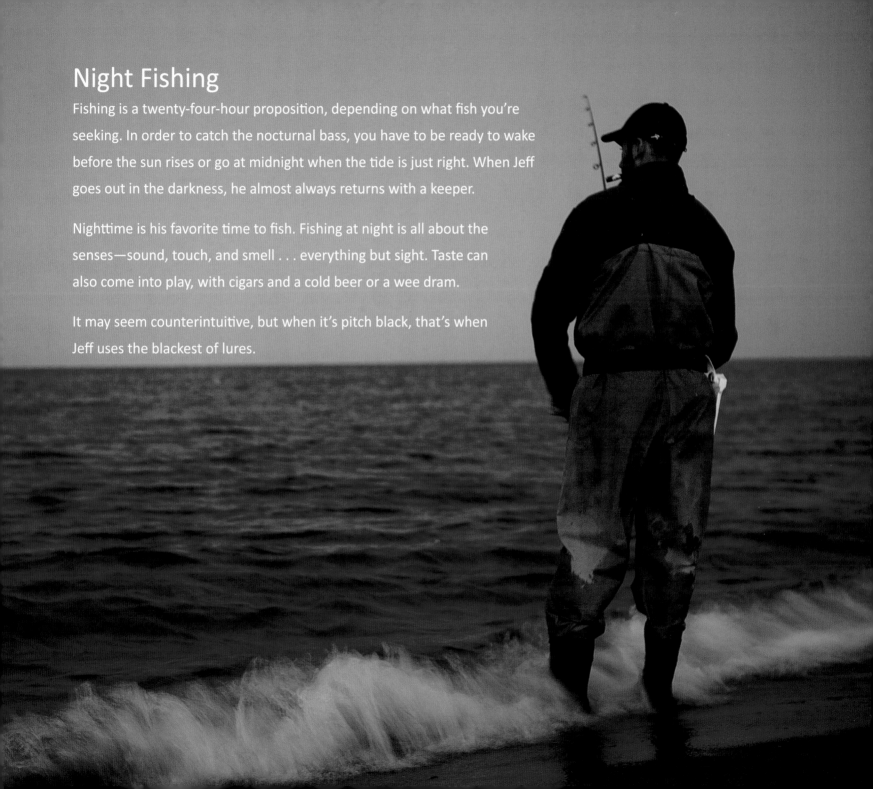

Night Fishing

Fishing is a twenty-four-hour proposition, depending on what fish you're seeking. In order to catch the nocturnal bass, you have to be ready to wake before the sun rises or go at midnight when the tide is just right. When Jeff goes out in the darkness, he almost always returns with a keeper.

Nighttime is his favorite time to fish. Fishing at night is all about the senses—sound, touch, and smell . . . everything but sight. Taste can also come into play, with cigars and a cold beer or a wee dram.

It may seem counterintuitive, but when it's pitch black, that's when Jeff uses the blackest of lures.

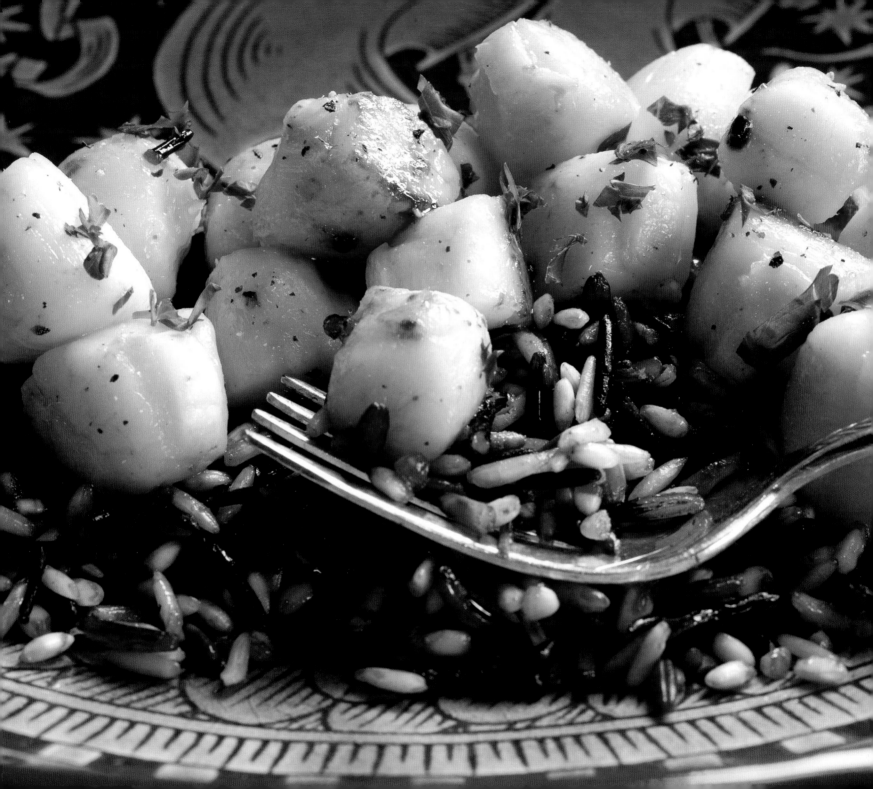

Late Summer Scallops

With each new month there's a new choice of seafood to look forward to. In the fall when the water is a deeper hue and crystal clear, and the air is cool and crisp, we get excited about the hunt for bay scallops. It takes time to find the spots, the water can be frigid, even with waders, and once you have your riches, you have to go home and shuck all those babies. But the rewards don't get much better than sitting down to a plateful of these sweet little nuggets.

This is so good with wild rice or pasta on the side. Take your leftover butter and lemon and pour over either, then top off with fresh chopped basil or parsley.

What you need:
Bay scallops
A few tablespoons of good-quality butter
Lemon

In a cast-iron pan melt the butter and squeeze the juice from a lemon into the butter.

Add the bay scallops to the pan and cook for 1 minute.

Turn them and cook another half a minute.

That's it!

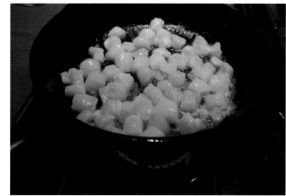

Nighttime out here is like living in a planetarium. The stars are breathtaking, the Milky Way is at its brightest, the constellations are never clearer, and the shooting stars are mesmerizing. You feel the vastness and wonder of the universe.

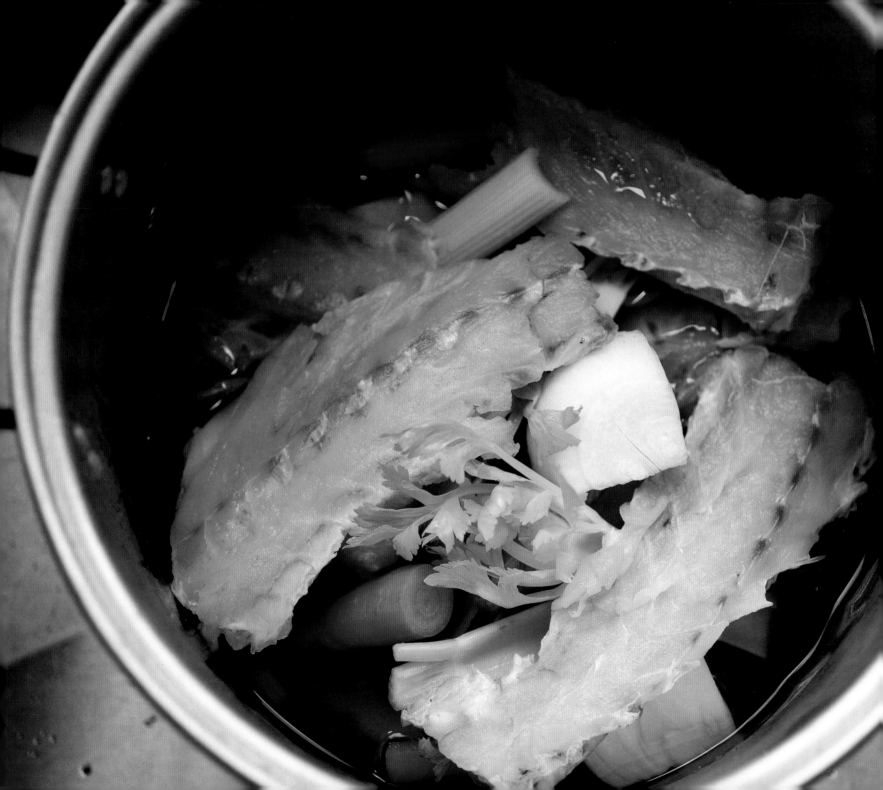

Fish Stock

The chef on a ship guards the fish stock like a pirate does his treasure. It's ready to go when good things come in from the sea.

What you need:

Fish bones from the catch of the day (I prefer striped bass with the head and tail cut off, and I like to use 2 or 3 fish)

Few stalks of celery

2–3 carrots, skinned and cut in half

1 large onion quartered and stuck with 5 or 6 cloves

Handful of peppercorns

Salt to taste

Add all ingredients to a large stew pot and cover with cold water.

Bring to a boil, skimming off the "scum" for a clear broth.

Simmer for an hour. Pour soup through a strainer and discard the solids.

Salt to taste.

Refrigerate for 1 or 2 days or freeze.

The stock can have a gelatin-like consistency after being chilled. This will add body and rich flavor to your chowder or gumbo.

Sleep Comes Easily

The first scent of mustiness on the sheets removed from the cedar chest, the smell of sand on wet pine board, and I am ready—for the heavy relief of sleep.

The wind and the sun conspire during the day to wear away the full sheen of work-a-day life from the outside in. Then at night, the peepers, the crickets, and the rock of the sea repeat the same refrain until I drift off on their rhythm.

Add to this the fact that I often spend my physical reserves during Chappy days, and there is little energy left at night for worry or frustration.

Chappy sleeps at night. Its breath slows and deepens, inviting us to join its slumber.

—B.W.

Ghost Stories

When our kids were young they would head out to the bunkhouse at bedtime in eager anticipation of another ghost story. The bunkhouse had been built as a coastal watch tower during World War II and made a perfect setting for the oft-told scary tales.

The watchtower, moved from its original place on the Wasque shore, is now only about fifty feet from the main house, but on stormy nights when thoughts of monsters and ghosts danced in the children's heads, it must have seemed like fifty miles.

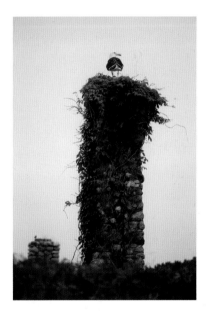

Jeff would quietly open the door and enter their world. The kids would be poised in their beds, sometimes doubled up, and usually nervously giggling about what was to come. In a soft voice so that the kids had to lean forward to hear, Jeff would slowly begin his tale. The Beast of Katama Bay, the Little Lost Boy at the Chimneys, or the Hunchback of the Lighthouse.

They were all familiar, and yet each time there was some new detail. The kids would practically fall out of their beds as they leaned forward for every last scary detail, then quick as a flash, Jeff would shine a flashlight on his face and in a booming voice bring the story to a terrifying end. Screams were heard all the way to the main cottage.

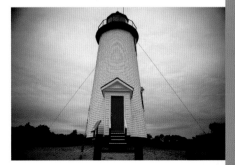

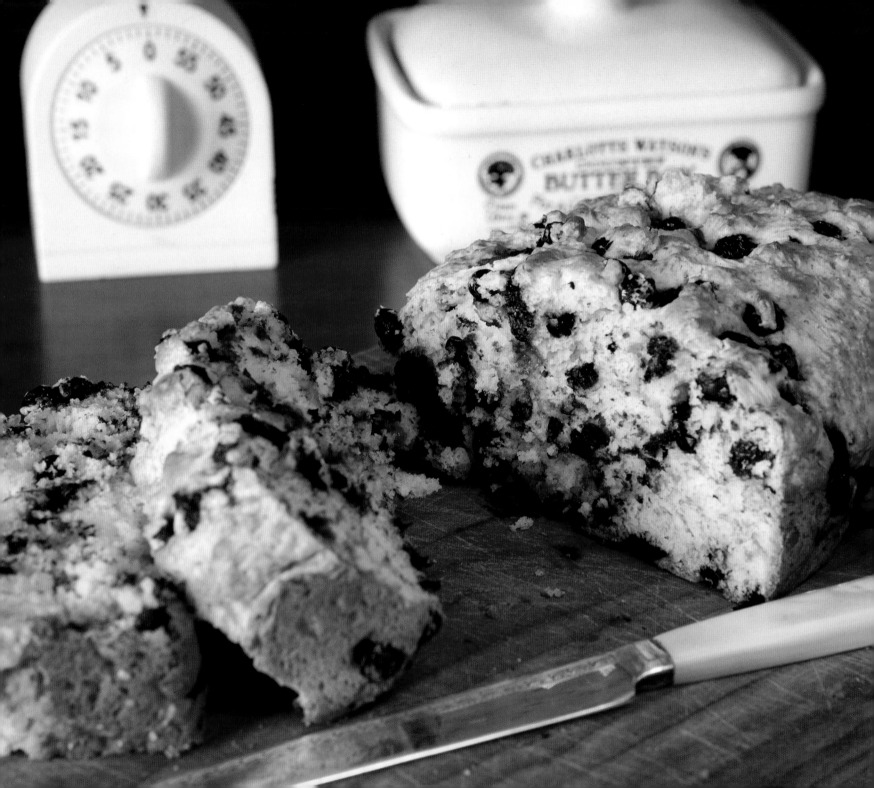

Blueberry Bread

My mother had a favorite cookbook written by a woman named Elsie Masterton, who ran a summer inn in Vermont with her husband. My parents visited their inn many times, and they loved this bread. It reminds me of baking powder biscuits. I've halved the recipe, which makes enough for one loaf.

What you need:

1 egg
1 cup sugar
1 cup milk
⅛ cup good-quality sweet butter
1½ cups flour
½ teaspoon salt
2 teaspoons baking powder
1 cup fresh wild blueberries
1 tablespoon flour

Beat together the eggs and sugar. Add milk and melted butter.

Sift the flour, salt, and baking powder and add to the liquid ingredients.

Mix until just combined; don't worry about making it smooth.

Toss the blueberries in flour, using just enough to cover them. This keeps them from sinking to the bottom.

Fold the berries into the batter.

Pour into a well-greased bread tin.

Bake at 350 degrees for 30 minutes, or until a toothpick comes out smooth. Let cool before cutting.

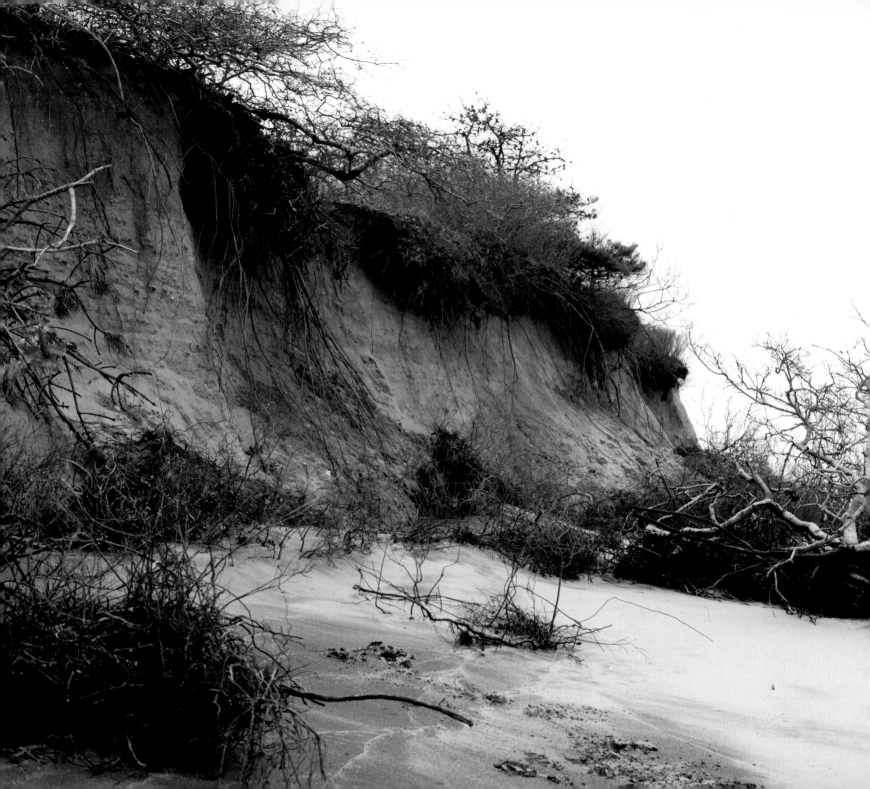

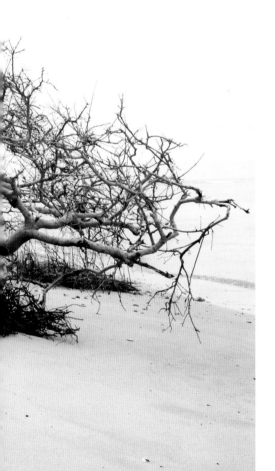

Change

Conditions on Chappaquiddick are constantly changing. Every year there is something new to adapt to. One year the nesting plovers restrict travel on the beach roads. The next year a massive storm cuts a hole in the barrier beach that fronts Katama Bay, which our cottage overlooks. Erosion has altered some of our favorite fishing spots and beaches. Beautiful boardwalks built by The Trustees to meander through the sea grass have been swept away. If you study the maps over the last two centuries, you will notice the cyclical nature of it all. We take comfort in the knowledge that one day breaches will close up and the beaches will be restored.

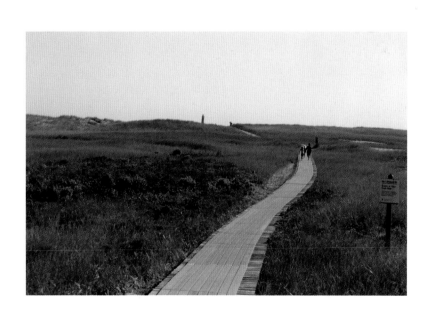

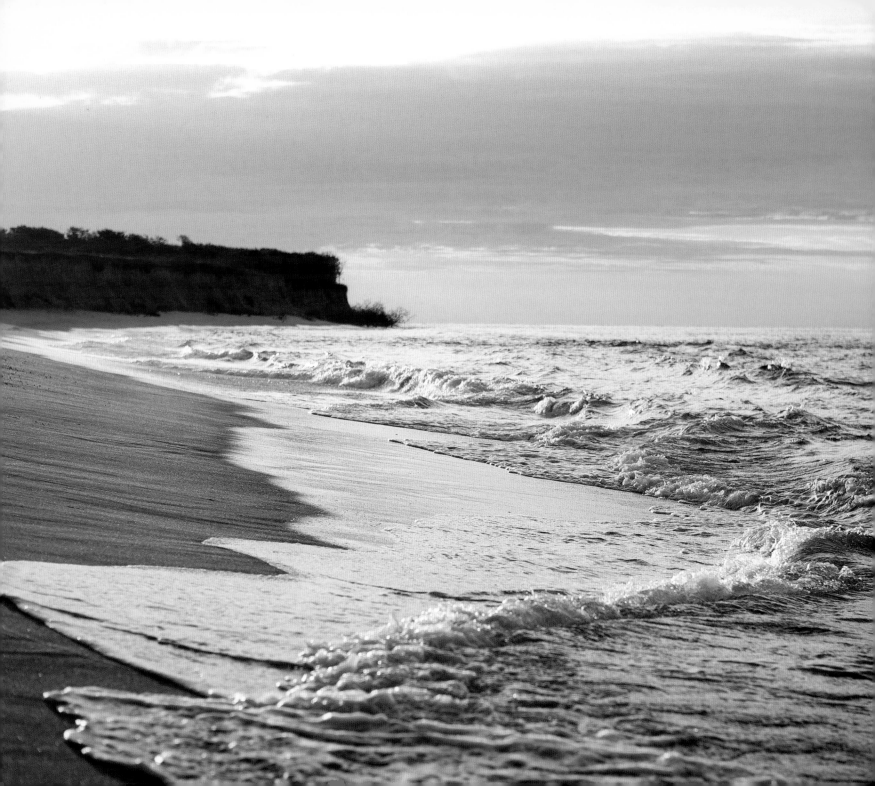

Watching the flocks of migratory birds on the beaches of Chappaquiddick could be a fulltime job. The Trustees of Reservations have specialists who monitor the nesting birds and protect them until their babies are safely hatched and fledged.

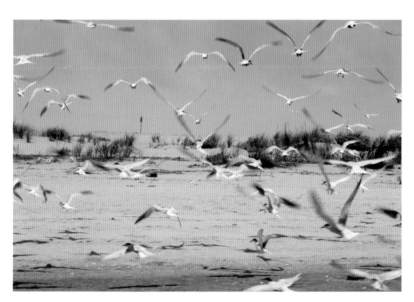

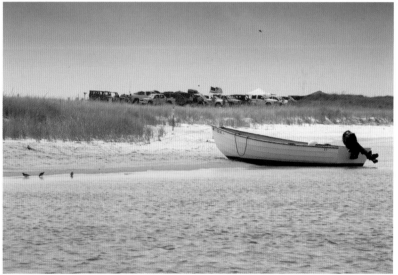

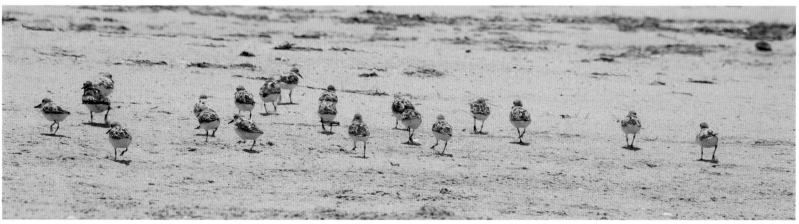

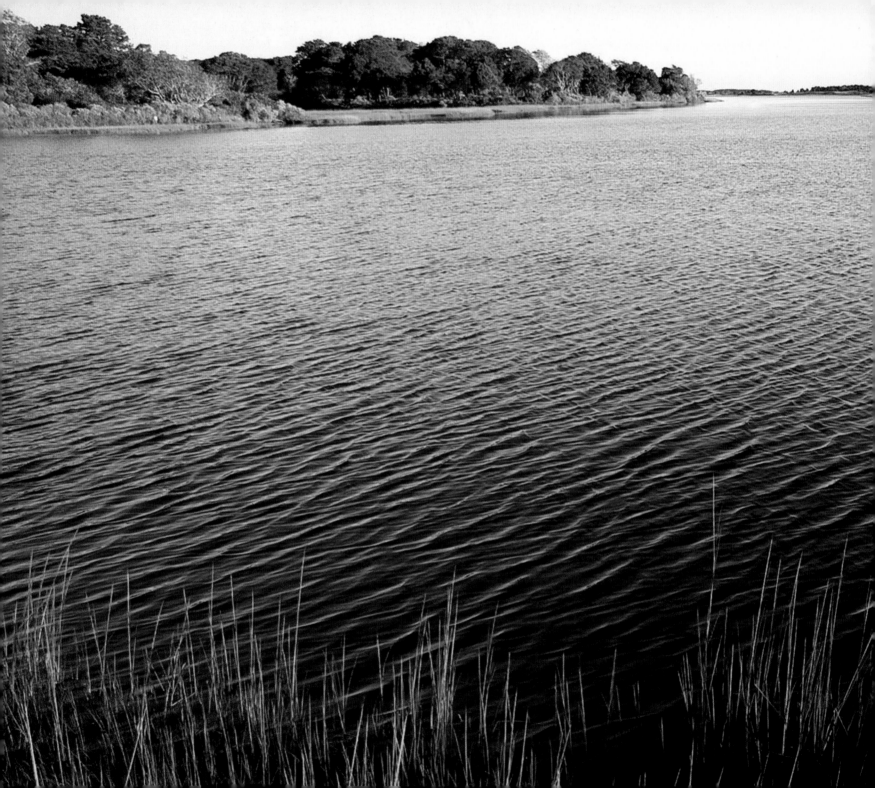

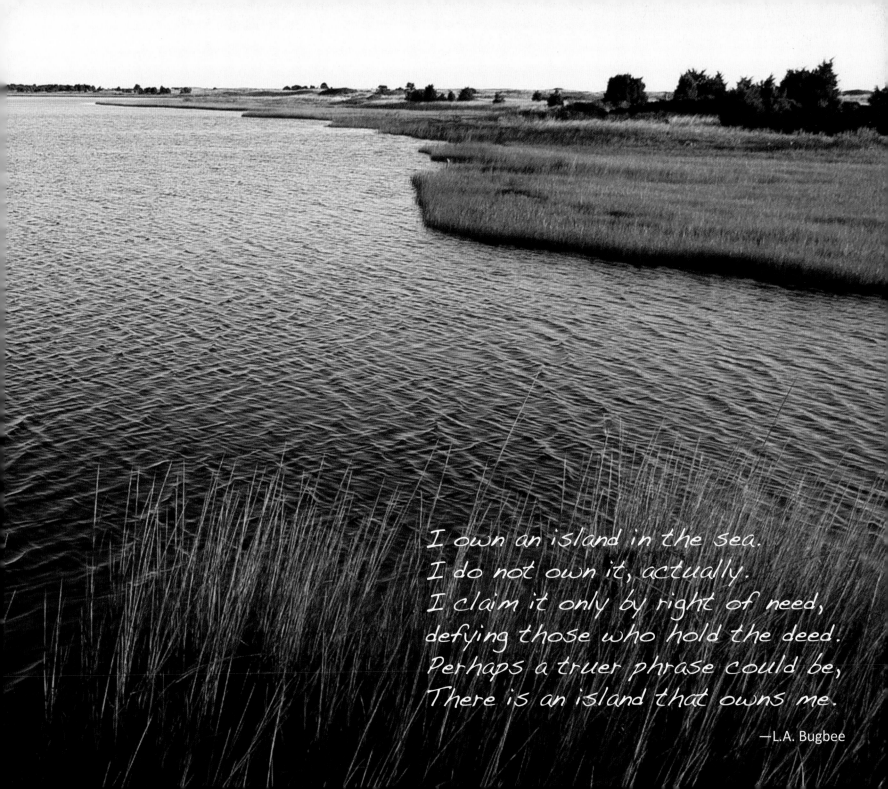

I own an island in the sea.
I do not own it, actually.
I claim it only by right of need,
defying those who hold the deed.
Perhaps a truer phrase could be,
There is an island that owns me.

—L.A. Bugbee

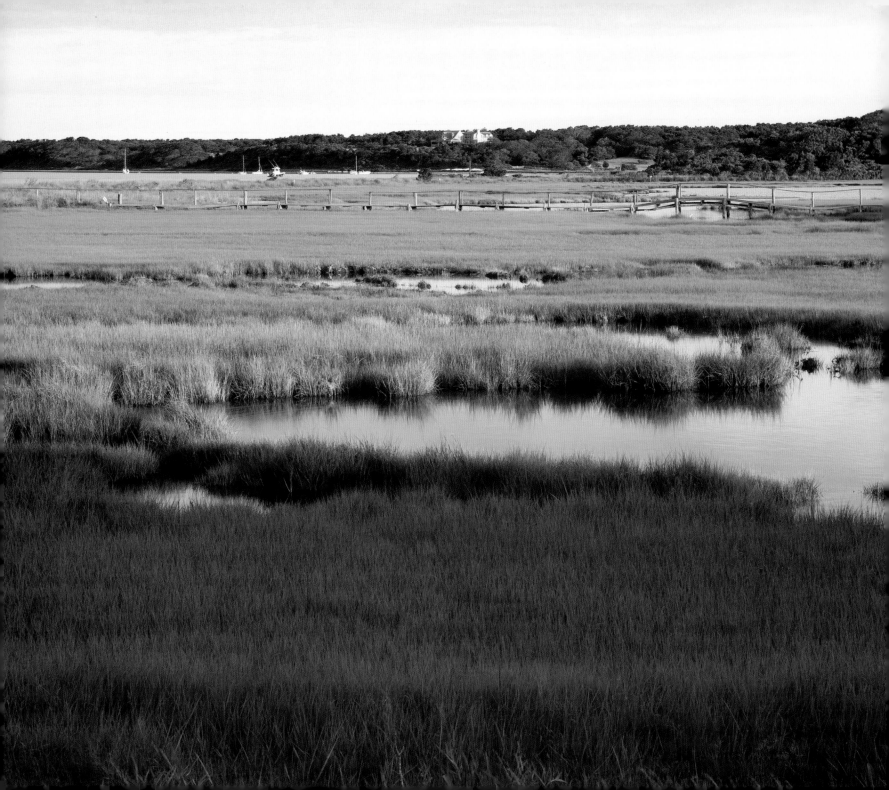

Resources

Slip Away Farm
Sown by the Sea on Chappaquiddick

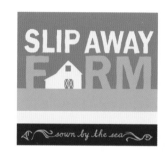

Slip Away Farm is a small farm dedicated to bringing organic vegetables to the community through both a weekly farm stand and community-supported agriculture (CSA).

Lily Walter owns and operates the farm, along with help from her partners, Jason Nichols, Collins Heavener, brother Christian Walter, and their little dog, Baxley. They live in the antique Marshall farmhouse directly across from the Chappy Community Center, where they grow and sell vegetables, eggs, honey, coffee, and various home-baked goods. The farm has become a welcome gathering place to stock up on fresh vegetables and catch up on the news of the island.

Visit www.slipawayfarm.com for more information.

The Trustees of Reservations

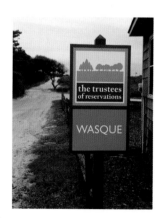

There are few places in New England where the waterfront is as wild and untouched as on Chappaquiddick, and that is due in large part to The Trustees of Reservations. It is a nonprofit conservationist organization dating back to 1891 that owns property all over Massachusetts. Its mission on Chappaquiddick is to preserve and protect our wildlife and coastal plains while making these exceptional properties available for public use and enjoyment. The rangers who work for The Trustees maintain miles of beach and inland waterways, including the Cape Pogue Wildlife Refuge, and Wasque.

Visit www.thetrustees.org for more information.

Creative Team

Melinda Fager is a photographer and graphic designer. She owns the Great New England Apple Company, which produces award winning applesauce. Melinda and her husband, Jeff, live in Connecticut and New York City when they're not on the Vineyard. They have three grown children.

When **Jeff Fager** is not fishing, he's chairman of CBS News and executive producer of *60 Minutes*. This entire book is a loving collaboration between Melinda and Jeff and their thirty years on Chappy.

Essayist **Brad Woodger** grew up coming to the North Neck side of the island and spending summers in the Big Camp, the family home his great-grandfather designed. Brad watches the people, seasons, and tides come and go from his perch on the bluff of North Neck. Many days he sees more birds than persons. That's okay with him. He has been a writer for the *Vineyard Gazette* for several years.

Illustrator **Dana Gaines** spent all his childhood summers on Chappaquiddick in a cottage his dad built, which he rents during the summer season. Dana has illustrated houses, maps, lighthouses, jigsaw puzzles, and two other books for Vineyard Stories. He is an avid kayaker. When tenants had their hearts set on a specific puzzle, Dana kayaked across Katama Bay from Edgartown to hand-deliver it to them.

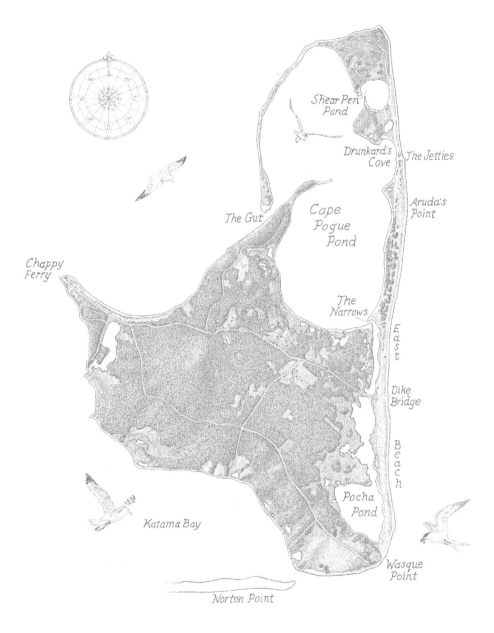

The Island of Chappaquiddick

Shear Pen Pond

Drunkard's Cove

The Jetties

Aruda's Point

The Gut

Cape Pogue Pond

Chappy Ferry

The Narrows

East Beach

Dike Bridge

Pocha Pond

Katama Bay

Wasque Point

Norton Point

Acknowledgments

Thanks to...

Alison Shaw, who encouraged me to pursue this book after I completed one of her outstanding photographic workshops.

Tim Clapp, our wordsmith friend, who helped refine my copy.

The professionals at Photographic Solutions of Norwalk, Connecticut, who did a great job converting my film negatives to digital.

Edo Potter, who has spent her lifetime on Chappaquiddick. She has given me a better understanding and appreciation for the history of our island.

Jocelyn Filley—another fellow islander, for her beautiful photographs showing me at work in the kitchen.

Jill Dible, the talented book designer who took the manuscript and photographs and turned them into a thing of beauty.

Jan Pogue, publisher of Vineyard Stories. Without her this would never have happened. She guided my idea into this book, and I am forever grateful.

The Sears family, especially Keith and Kit, who shared their home with us for years, and eventually sold it to us. They're the very best of people.

*"On the day of departure,
keep in mind the anticipation of return."*

—Henry Beetle Hough, author, conservationist,
longtime editor of the *Vineyard Gazette*